BRAINTREE & BOCKING
THROUGH TIME

John & Sandra Adlam

AMBERLEY PUBLISHING

Acknowledgements

Linda Goodrich and Robert Rose – Braintree District Museum Service
Ruby Goodwin
Michael Bardell
Geoff Fuller – Braintree Town Hall Centre
Christine Roberts and Aaron Smith – The Bull public house, Braintree
John, Tom and Iona Vignoles

First published 2009

Amberley Publishing Plc
Cirencester Road, Chalford,
Stroud, Gloucestershire, GL6 8PE

www.amberley-books.com

British Library Cataloguing in Publication Data.
A catalogue record for this book is available from the British Library.

ISBN 978 1 84868 311 2

Typesetting and Origination by Amberley Publishing.
Printed in Great Britain.

Introduction

Images of the past using old postcards can only go back to 1898, and whilst it may seem that capturing images from the present should be easy, especially with the advent of digital photography, it can sometimes be difficult to pinpoint the exact location for comparison as so many changes have taken place over the years.

Braintree and Bocking were once two separate towns, which were united into one community in 1934 following an act of parliament in local government matters. Evidence of Bronze Age, Iron Age and Roman occupation has been found and in 1199 King John granted a charter to the bishop of London for a weekly market in Braintree, which is still held to this day.

In the Middle Ages, Braintree became an important town for travellers from the Midlands en route to the Low Countries through Harwich, and for pilgrims journeying from the south of England to visit the shrines at Bury St Edmunds and Walsingham.
The wool trade flourished in Braintree and Bocking from fourteenth century, to be replaced in the nineteenth century by silk, with Warners and Courtaulds being the largest manufacturers. As will be seen, the Courtauld family became great benefactors to the towns.

With the advent of the railway, several engineering firms became established, including Crittall Windows, Lake & Elliot and Bradbury's. Sadly, all of these large industries have gone and although there are numerous new employers on several industrial sites, many residents daily take the train to London; the growth of Stansted Airport and the designer outlet village of Braintree Freeport offers more opportunities for employment.

Hopefully this collection of old postcards and their modern partners will rekindle memories for some and give new residents an insight into the past of Braintree and Bocking.

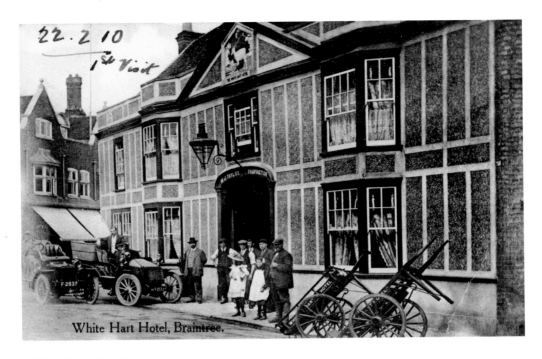

White Hart Hotel, Braintree.

White Hart Hotel

Although thought of as the centre of Braintree, the White Hart Hotel is officially in Bocking. After St Michael's church, this is one of the oldest buildings in the modern town, parts of which have been dated back to 1375, and there may have been a Roman structure on this site. This old coaching inn was an important stopover for coaches leaving London bound for Suffolk and Norfolk.

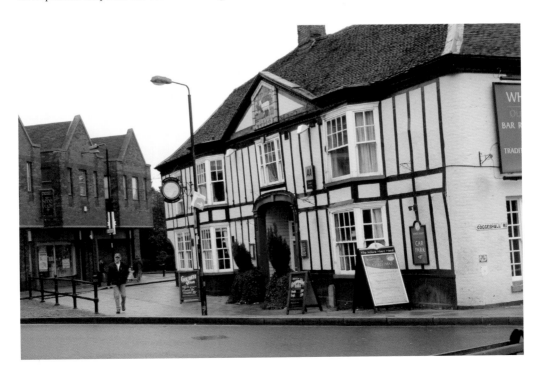

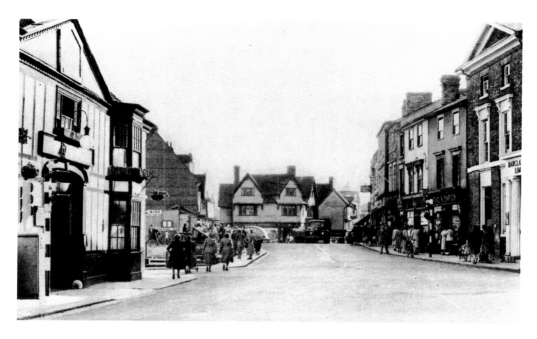

Bocking End

As traffic through the town became heavier, and before the advent of the Braintree by-pass, it could sometimes take an articulated lorry half an hour to negotiate this junction, thus causing chaos in the town! The Braintree district sign seen just beyond the White Hart Hotel in the new photograph was unveiled by Sir John Ruggles-Brise in March 1977.

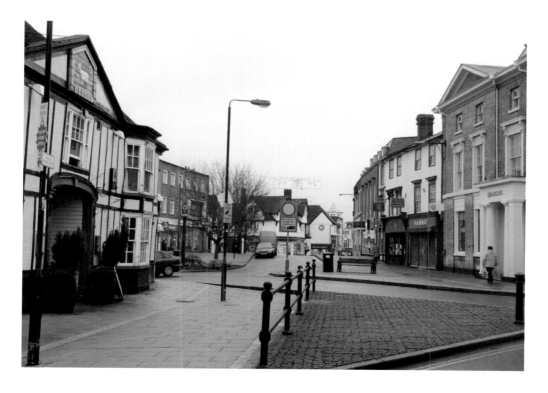

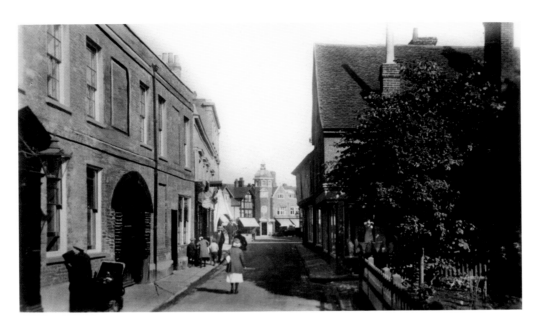

Bank Street

The garden on the right which belonged to Dr Harrison, who lived opposite, was demolished along with the shops beyond in the 1930s to make way for the large open space seen today. The clock tower seen in the background was a familiar part of the Braintree & West Essex Co-operative Society building until its demolition in the 1960s. Since the new view was taken, Woolworth stores have closed throughout the country.

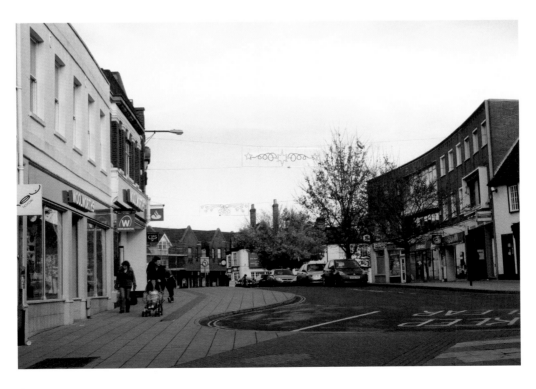

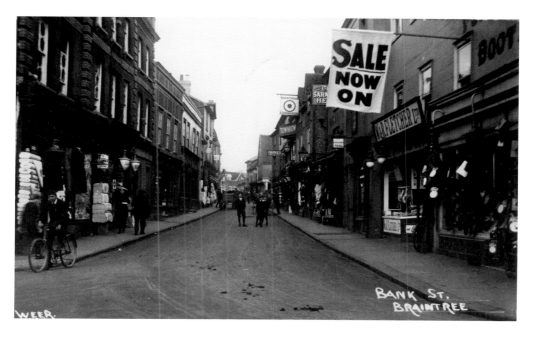

Bank Street

On the right can be seen W. & R. Fletcher (Butcher), the Saracen's Head public house, Bartram's gun shop and Townrow. All of these businesses have now gone except for Townrow which has premises in the High Street. The building on the left dates from the fifteenth century; in October 1987 a fire on this site damaged the premises of Visionhire, Hogg Robinson Travel and Dewhurst the Butchers. Although two of the shops were rebuilt, it became the entrance to George Yard Shopping Centre.

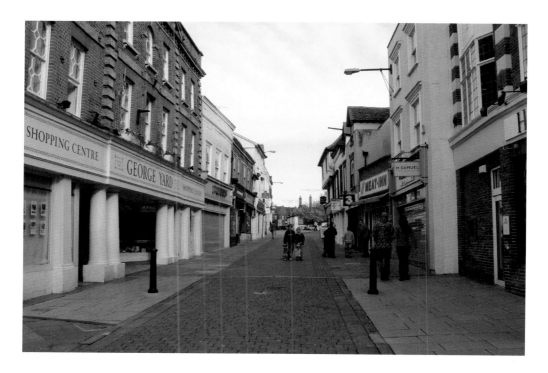

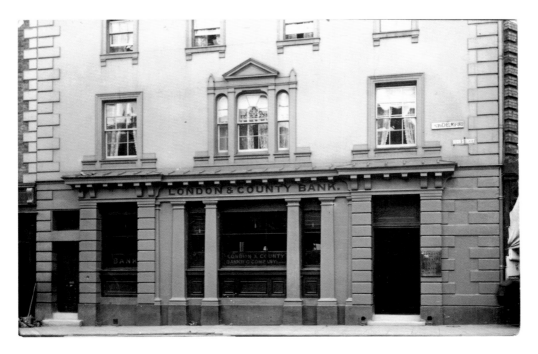

High Street

This card, dated 1909, shows the London & County Bank with its very ornate frontage. Now much simplified, it is still identifiable, although it is a shame that some of the first floor windows have been partially obscured. The small shop on the left, now City Barber, was for many years The Chocolate Box, a lovely old-fashioned sweetshop.

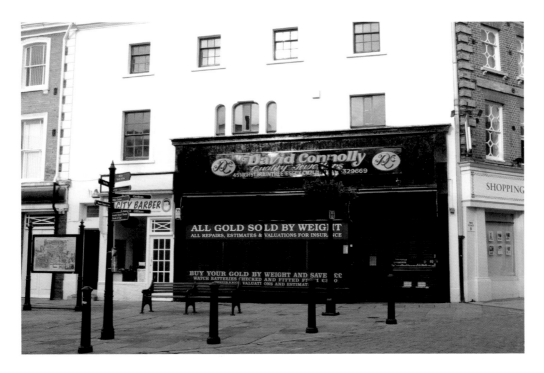

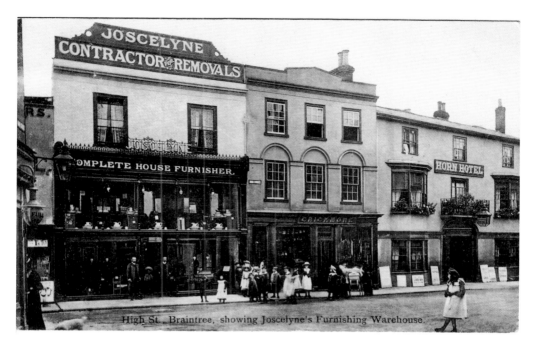

High St., Braintree, showing Joscelyne's Furnishing Warehouse.

High Street

Joscelyne were established in 1777 and had a shop in Braintree for over two hundred years. This picture is taken from one of their advertising cards with a printed message on the reverse and was used to send best wishes for 1906 to Hillingdon, Middlesex and posted in Worthing, Sussex! They later took over the shop to the right which was Crickmore's, a harness and saddle maker, whose services might possibly have been used by travellers using the Horn Hotel, another of Braintree's coaching inns.

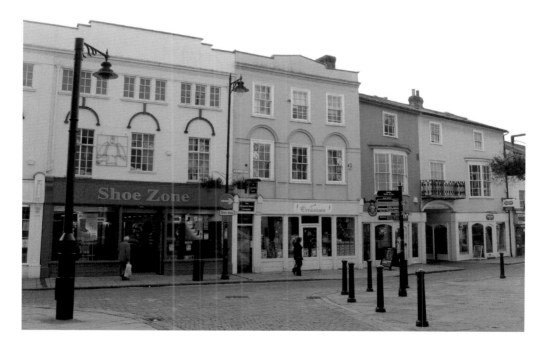

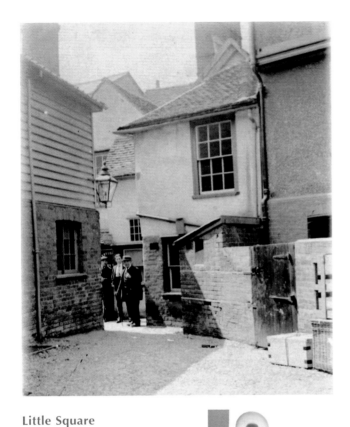

Little Square

The original medieval market was in the Little Square, Great Square and Bank Street area and when the market stalls became more permanent structures, the passageways were called 'gants', a name that seems to be peculiar to Braintree. The gant shown here runs from Little Square to Bank Street passing Phillers Sandwich Bar and Café and Cash Converters.

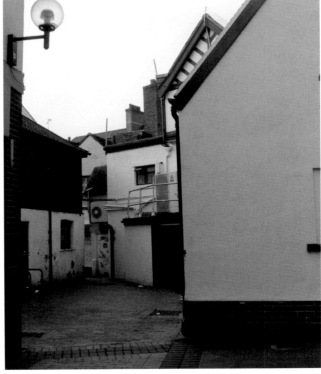

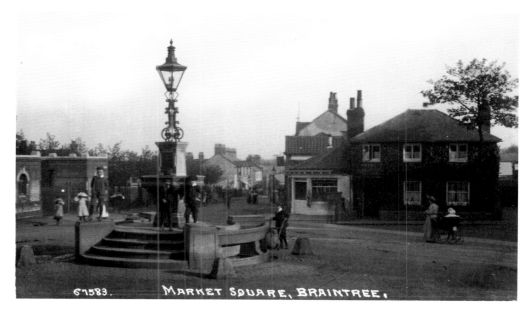

Market Square

These views show the much changed face of Market Square. On the left where the cattle market used to be is the town hall, then the post office building which is now the job centre, and beyond is the Embassy Cinema which is now part of the J.D. Wetherspoon chain, whilst on the extreme right is Tesco, built in 1975. Even the top of the drinking fountain has changed!

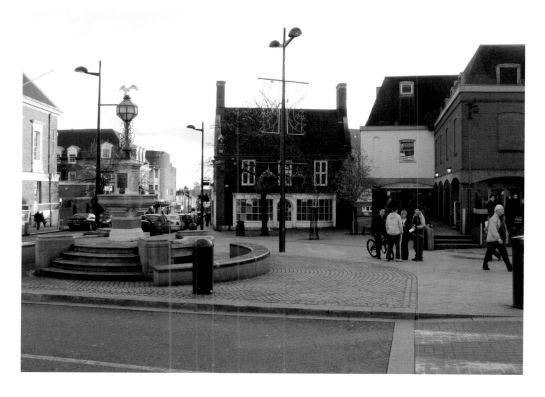

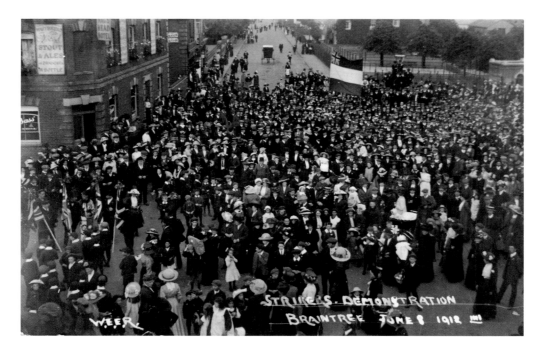

Market Square

The photographer, having climbed to the top floor of the Bull public house, has drawn the attention of the crowd away from the strike leaders. These were possibly Crittall workers; another photograph taken on the same day describes the scene as a 'strike settlement celebration'. The Nag's Head public house, seen on the left, was built in the 1860s to replace the Globe, a beer house.

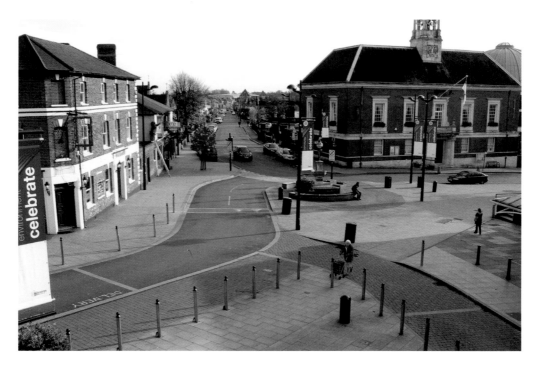

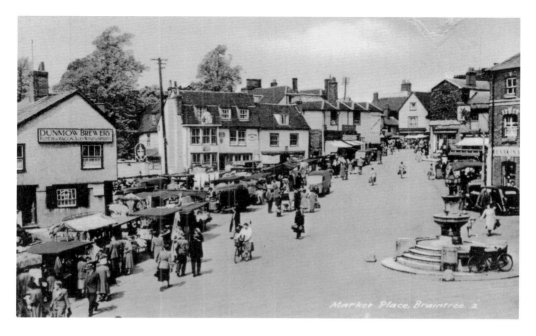

Market Place/Market Square

In 1199 King John granted the town a charter to hold a weekly market which is still held today, although the cattle market no longer exists. Long before the relaxation of the licensing laws, the public houses in Braintree were allowed to open between 2 and 4 p.m. on market days. The Crown and Anchor public house, on the left with the sign 'Dunmow Brewery', and part of the cattle market stood where Tesco is today.

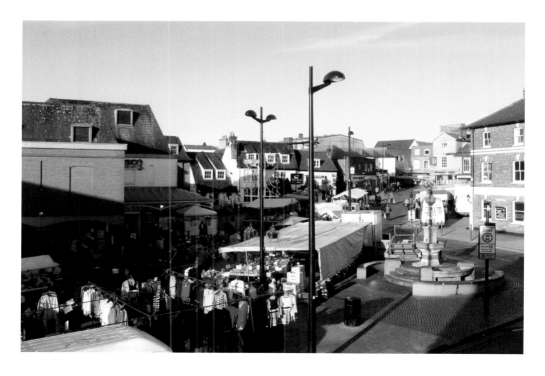

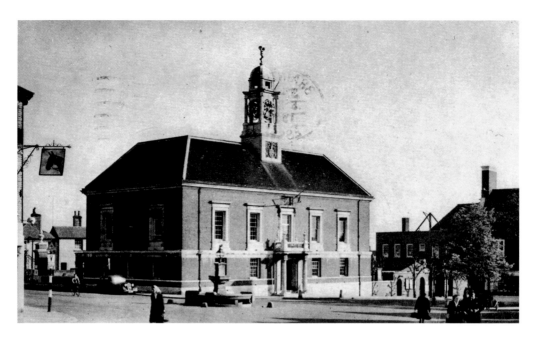

Town Hall

Opened on 22 May 1928, the town hall was funded by William Julien Courtauld and the foundation stone was laid by George Bartram, town councillor, on 16 October 1926. It housed the council offices from 1928 to 1981, when they moved to Causeway House. Just to the right of the town hall is the library which was opened in 1997, having moved from Coggeshall Road.

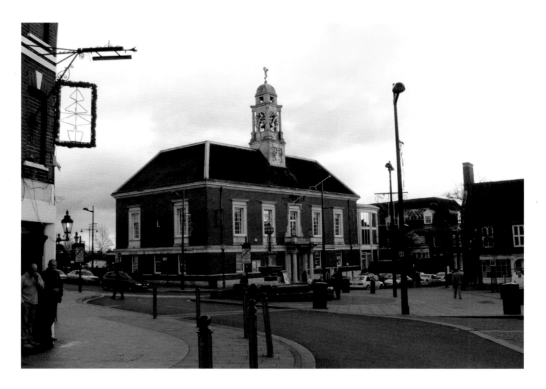

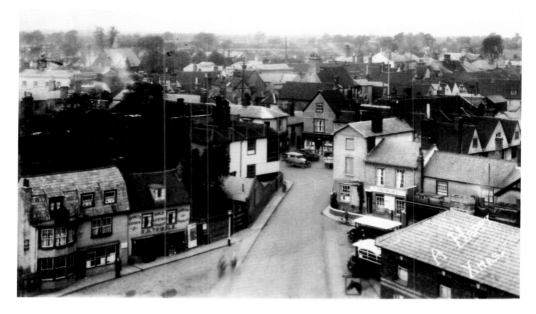

Market Square

These views were taken from the clock tower of the town hall; the green cupola is on London House on the corner of Bank Street and High Street. The Bull public house, seen on the left, now incorporates the adjoining premises which once belonged to R.H. Tribble, harness-maker. Much of the Market Square has been paved to encourage 'café-culture', as can be seen outside the Bull. On a fine day it is very pleasant to sit outside with a drink and a meal and watch the world go by.

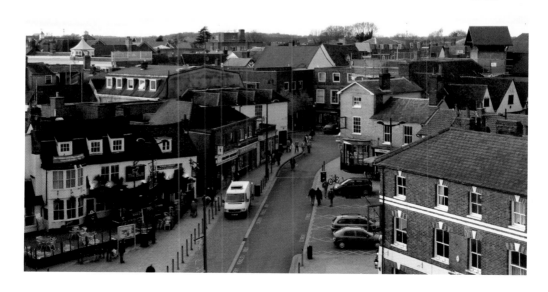

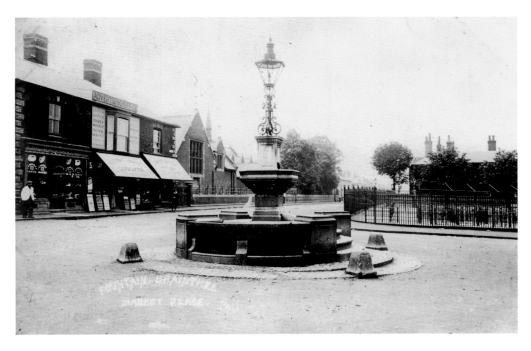

Market Square

Presented to the town by George Courtauld in 1882, although no longer in use, the drinking fountain is the focal point of Market Square. In 1980 the lamp was restored following damage by vandals; the owl on the top is believed to date back to the nineteenth century.

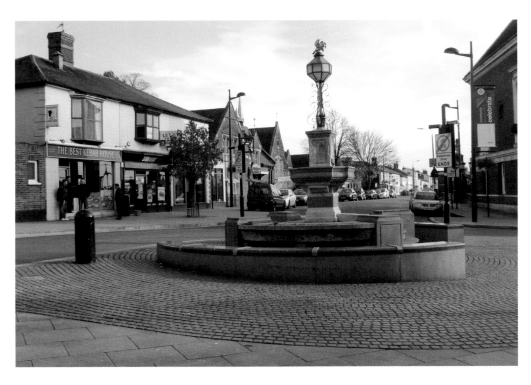

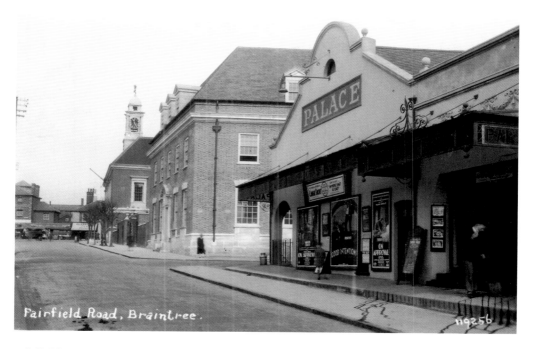

Fairfield Road, Braintree.

Fairfield Road

Opened in 1907, the Palace Cinema was rebuilt in the 1930s as the Embassy, featuring an art deco interior which still remains. The opening performance included Gaumont News, Disney cartoons and the feature film was *Things Are Looking Up*, starring Cicely Courtneidge and Max Miller. The large building to the left of the cinema was the post office opened in 1930 by George Bartram and is now the job centre.

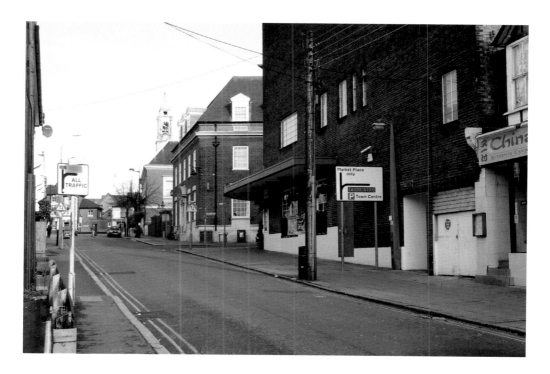

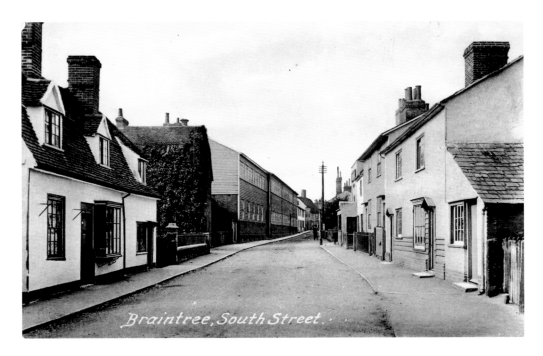

Braintree, South Street

South Street

The large white wooden-clad building centre left, known as New Mills, was built in 1856 by Daniel Walters and taken over by Warner & Sons Ltd in 1894. Fine cloth was woven here including coronation fabrics from the early 1900s. Although weaving has ceased here and the buildings now house various businesses, the vast collection of Warner fabrics and related items are now back in Braintree at the Warner Textile Archive in one of the buildings on this site, which is open to the public for part of the year.

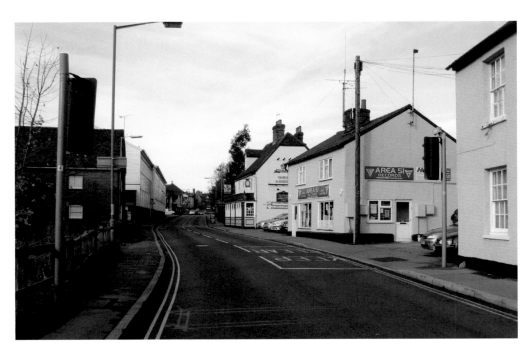

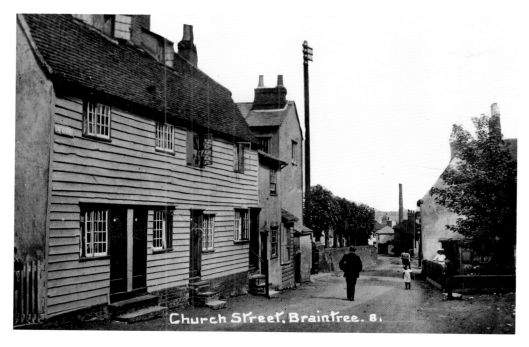

Church Street

On a map dated 1922 this has become St Michaels Road, as it is known today. Mr J. Bacon's shop, the Prince of Wales beer-house and some cottages were demolished to give an unimpeded view of St Michael's church.

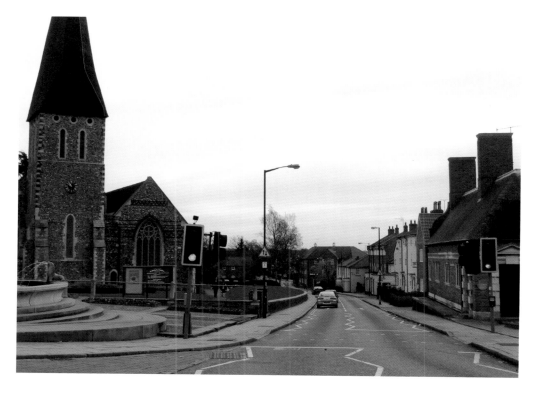

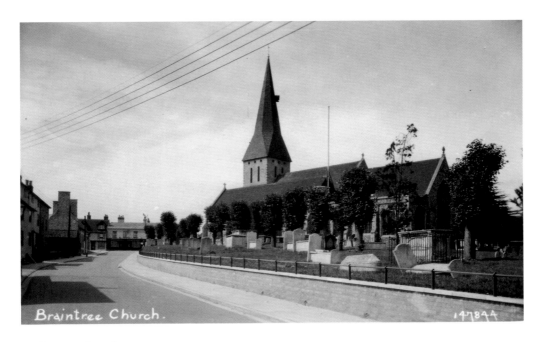

Braintree Church

The original church is thought to date from 1199 and was dedicated to Saint Michael the Archangel. Drastic restoration took place between 1864 and 1866 when the building became much as it is today. The most noticeable difference between the postcard, sent in 1943, and the new picture, is the removal of the headstones and trees. George Bartram was a church warden here for twenty-five years.

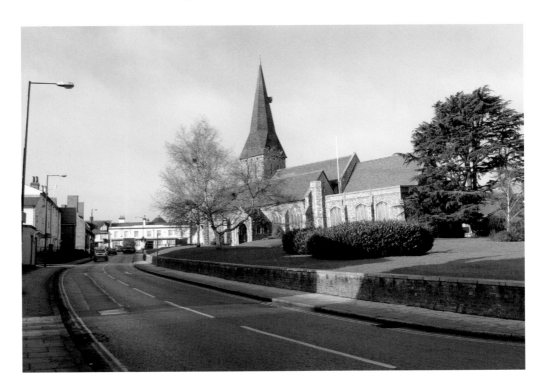

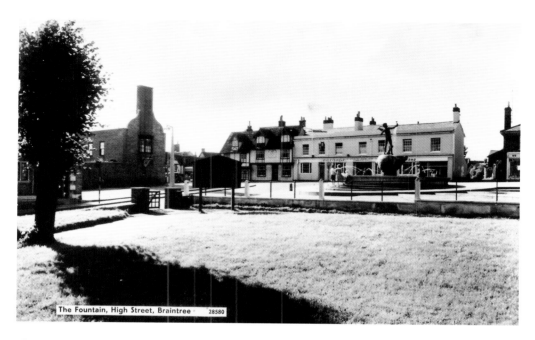

The Fountain, High Street, Braintree 28580

The Fountain, High Street

Funded by Sir William Julien Courtauld and erected in memory of King George V, the opening ceremony took place on 20 July 1937. It was performed by William Llewellyn RA, Sir W.J. Courtauld and G.T. Bartram. Two artistic cottages were also built on the opposite side of St Michael's Road, one of which was to be occupied by the caretaker of the fountain and surrounding area. The Wheatsheaf public house, seen behind the fountain, is now closed and is part of an apartment complex called Courtaulds Mews.

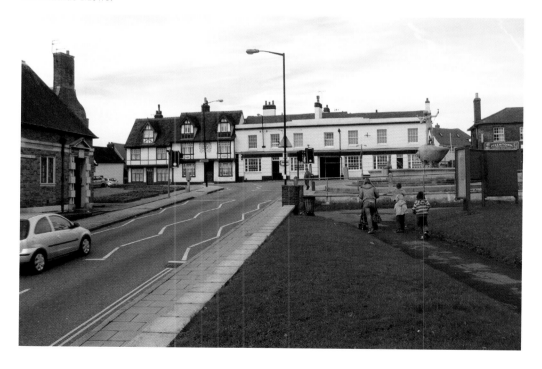

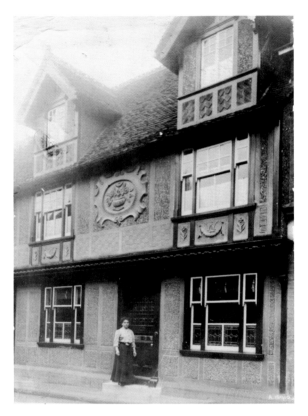

High Street

The front part of this Grade II listed building at 105 High Street is over 400 years old. The house, with land behind it, was bought by Walter E. Letch, builder and undertaker, to use for his family home and his business, which was established here by 1874; he also had premises in Bradford Street, Bocking. Following his death in 1893, his son, Augustus, took over and it is thought that he had the house repaired and altered. The lady standing at the door is probably Ada G. Letch, sister of Augustus, who would have been about thirty-six in February 1909 when she sent this card to Miss Fitch in Wethersfield; she writes 'A man came and worried me into helping to make a picture [!] whilst I was busy cooking'. The Letch family business flourished here for over a hundred years. In 2003, a few years after they ceased trading, the house was sold.

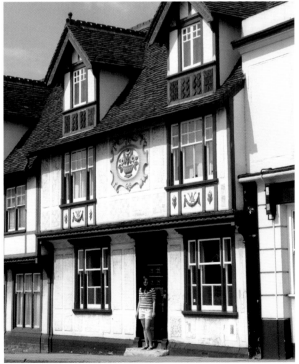

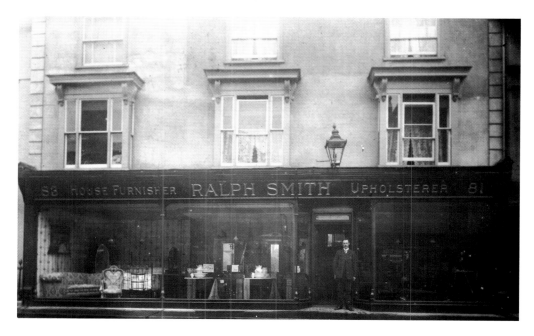

High Street

Ralph Smith, House Furnisher & Upholsterer, pictured on this postcard sent in January 1910, started his business in 1894 on the opposite side of the street in what is now Fleurtations flower shop. In 1908 the move was taken to these larger premises where they traded until 1977; it then became Glasswells Furnishers until 2001. It opened as the Litten Tree public house and restaurant, to be followed by Barracuda, also a bar and restaurant, but with a South African influence.

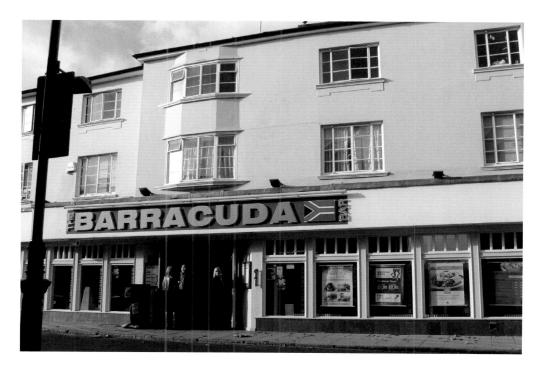

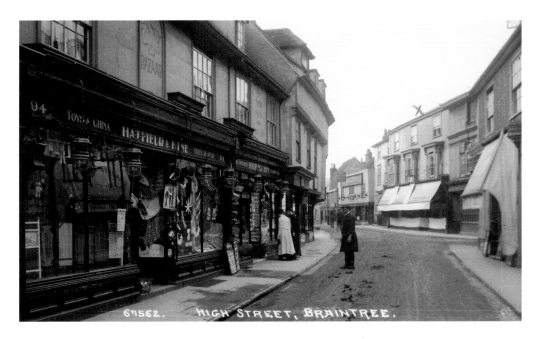

High Street

Written by a soldier on leave from the First World War to his 'own dear sweetheart', the reverse of the card above says that this is where he was staying (marked by the cross), which is over Ralph Smith's shop. The shop on the left is Hatfield and Hine where he probably bought the card. As only buses and delivery vans are allowed in this part of the street now, both scenes show little traffic.

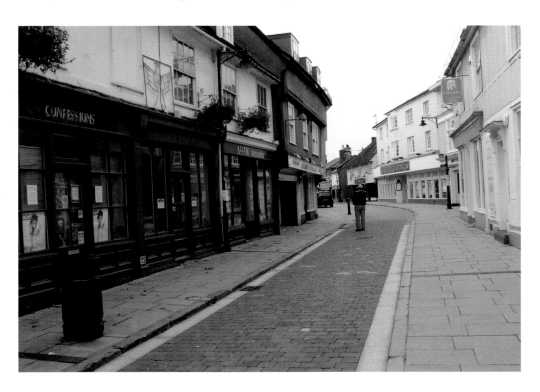

High Street

This view has changed very little; the building with the green cupola is London House which has replaced Fuller's Boot & Shoe shop (Fuller's factory was in Fairfield Road). On the left is the entrance to Sandpit Lane which now provides pedestrian access to George Yard Shopping Centre and the multi-storey car park.

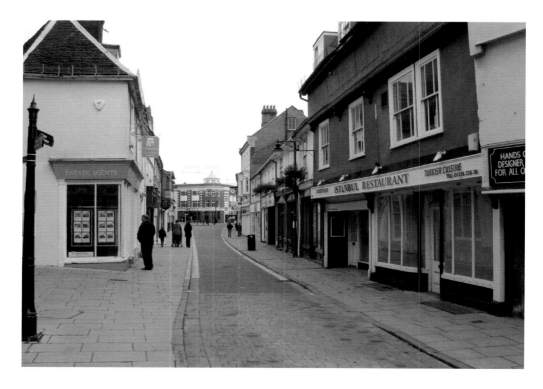

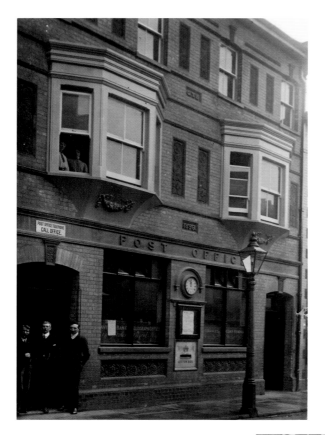

High Street

George Bartram had the Braintree Post
Office built in 1896 as he thought that, in
a growing and prosperous town, the post
office should have its own premises and
not be part of a shop. Since the post office
transferred to Fairfield Road, these premises
have been a bank, a shoe shop and now
Patrick & Menzies, opticians. Although the
ground floor has been altered, the upper
storeys remain the same and still bear his
initials 'G.T.B.' and the date. George would
probably be dismayed to know that although
the town is still growing, the post office went
into the Co-op in Rayne Road and is now in
another shop in New Street.

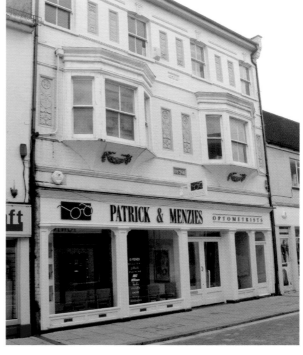

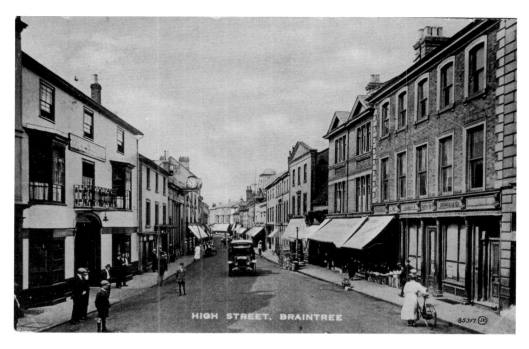

High Street

This postcard, from Will to his mother in Ilford and posted in Braintree at 9 pm on 5 May 1922, states 'If the weather is fine tomorrow I expect to be home to dinner.' The Horn Hotel, on the left, was a major coaching inn, with a central entrance and stables at the rear; it closed in late 1983.

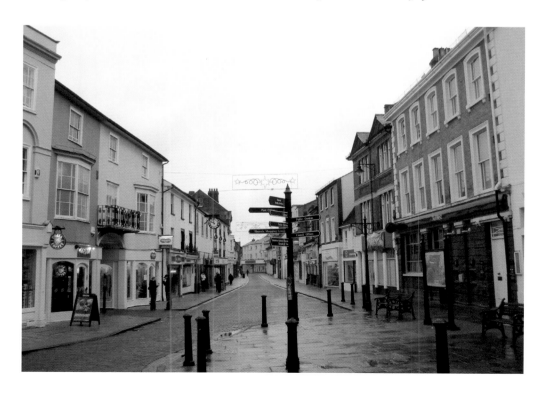

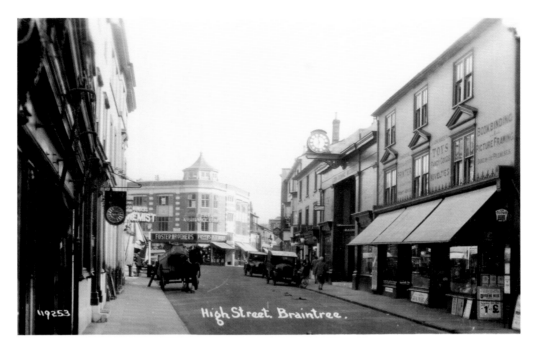

High Street

Fullers Boot & Shoe shop later became Foster Brothers' menswear until its takeover in 1977 by the Midland Bank, now HSBC. The mechanism for the clock above the Corn Exchange was inside the building and had to be wound once a week; this job was carried out by two generations of the Parkes family. After an absence of six years, the clock, now with an electric mechanism, was turned on by Tony Newton MP and hangs below the bracket.

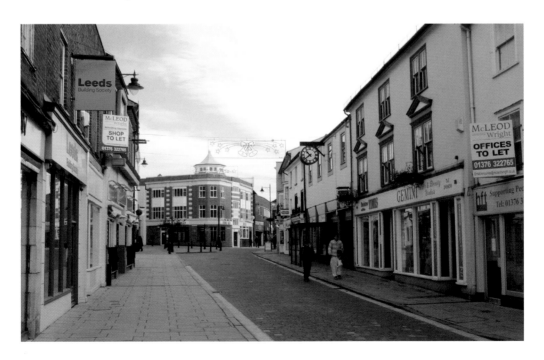

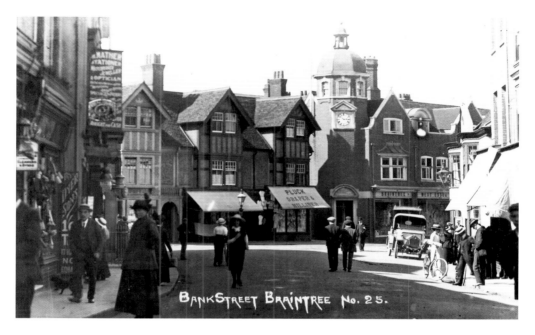

Bank Street

Not too much traffic was expected by these pedestrians in the road! Today you can still chat in much the same spot but only because of the altered road layout. Seen on the extreme right of the postcard is Blomfields shop which, along with several others, was destroyed by a bomb during the Second World War.

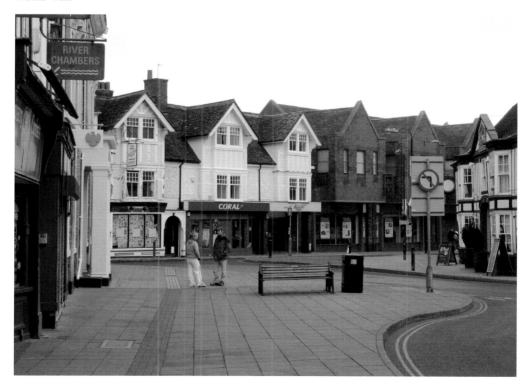

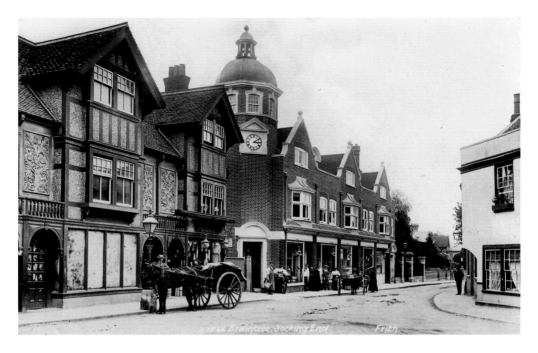

Bocking End

This scene from the 1920s shows the clock tower and premises of Braintree & West Essex Co-operative Society Ltd. Following rebuilding and extension, it was officially re-opened in 1907 and incorporated a hall, reading and committee rooms, an office, warehouse and stabling for eight horses. Obviously a thriving business, it later extended into the two shops to the left. Following demolition and re-building it became Wallis supermarket, then the International Store and is now Argos.

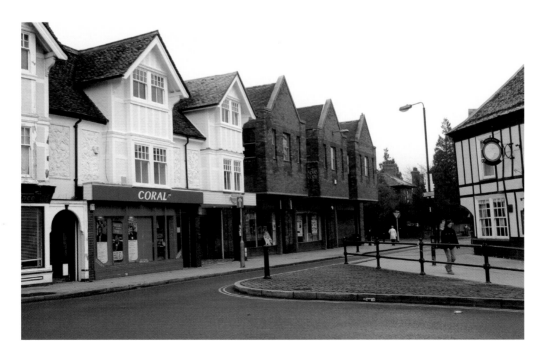

Bocking End

Known as 'The Institute', this building was given to the Braintree and Bocking Literary & Mechanics Institution under the will of George Courtauld in 1863, and was later reconstructed and enlarged by the family of Sydney Courtauld. It had a well supplied reading room and a library. Today most of the garden has gone but the premises are still well used, with many theatrical productions being staged here.

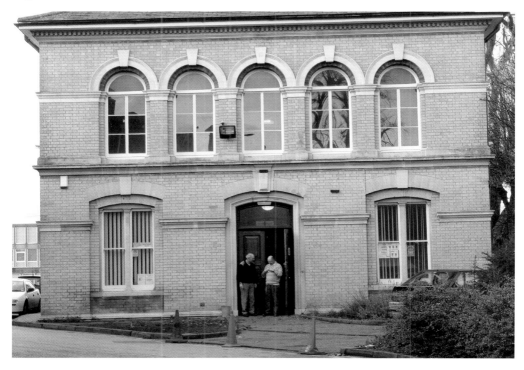

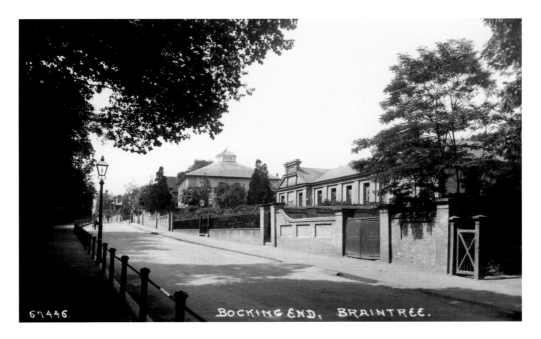

67446. BOCKING END, BRAINTREE.

Bocking End

The building with the small tower is the Congregational church which still remains although it is now dwarfed by Causeway House, purpose-built to house Braintree District Council offices in 1981 on the site of the British School, which was demolished in 1979. There is talk of the Council offices moving again to a new building behind the town hall, which was their home before 1981.

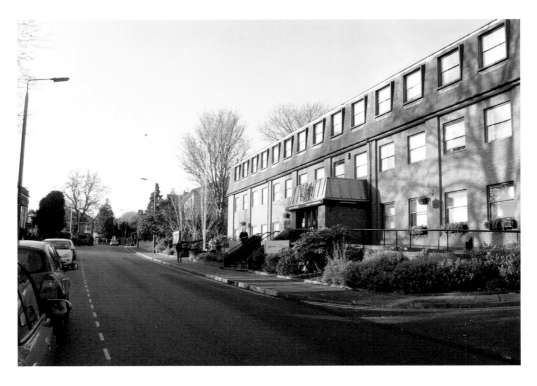

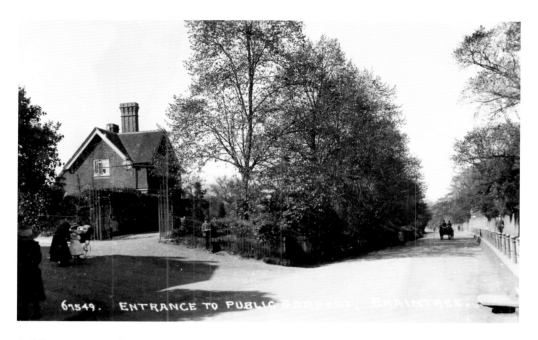

Public Gardens, The Causeway

The gardens were donated to the town by Sydney Courtauld and formally opened in 1888 by Sydney and his wife, Sarah Lucy; the cottage just inside the park gates was built for the park-keeper and his family. Apart from the cars and the new gates that commemorate the coronation of Queen Elizabeth II in 1953, this scene remains much the same as on the postcard sent on 26 July 1920.

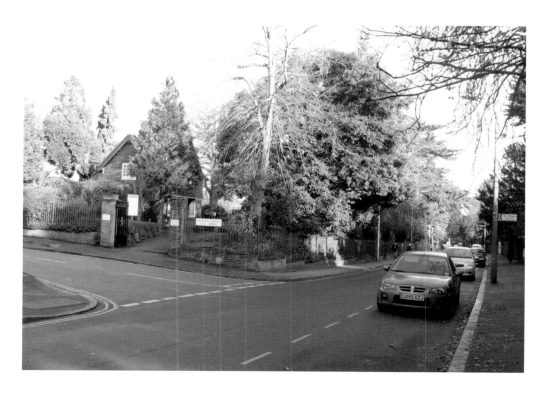

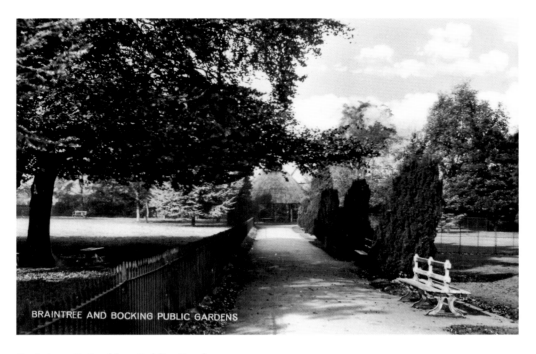

BRAINTREE AND BOCKING PUBLIC GARDENS

Braintree & Bocking Public Gardens

Grey squirrels were introduced into England in 1876, so when this postcard was published there would have been none in the gardens. Today there are many of them and they have become bold and expect to be fed by visitors enjoying a stroll. The park benches are the same and the bandstand and tennis courts are still used regularly.

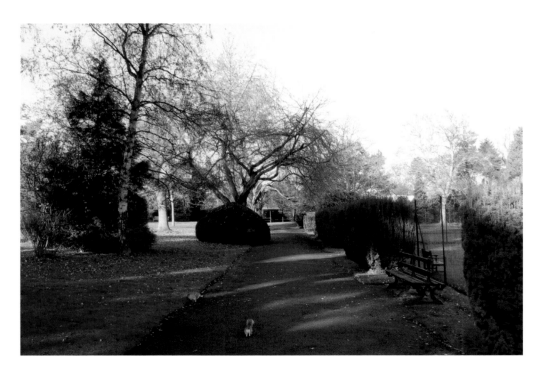

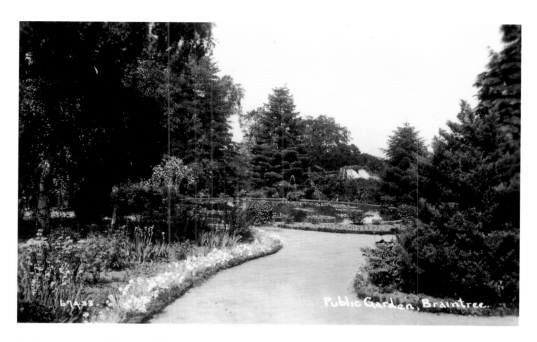

Braintree & Bocking Public Gardens

In early 1980 an appeal was launched to raise money to save the pond as it had been leaking for ten years. Today it is still a tranquil spot to visit with not many changes except that the gardens are not as formal as they once were.

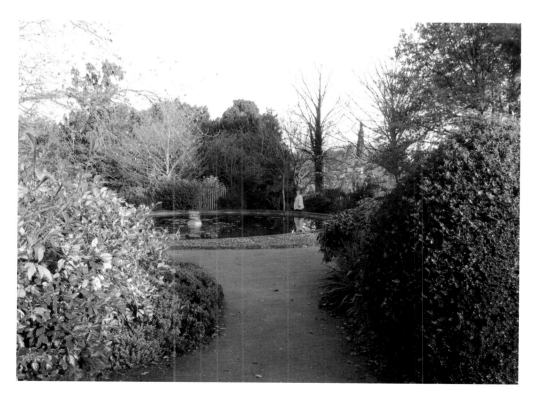

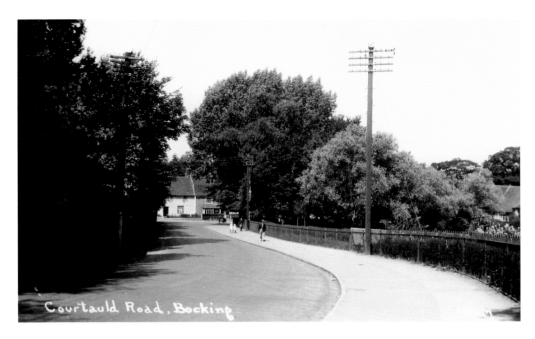

Courtauld Road. Bocking

Courtauld Road

Running from Coggeshall Road, these views show its junction with The Causeway and Bradford Street. Once a quiet road, it has become busier since the one-way system was introduced. The large conifer hedge, which must take a long time to keep in trim, is on the corner of Julien Court Road.

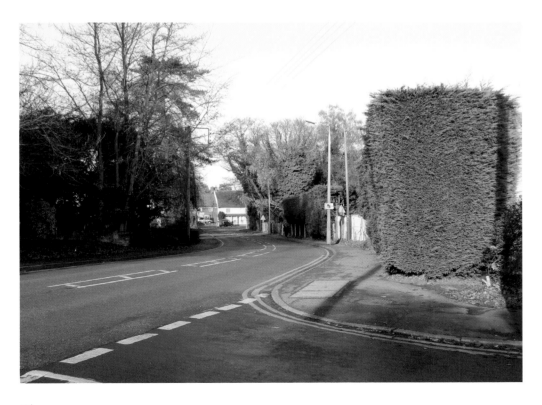

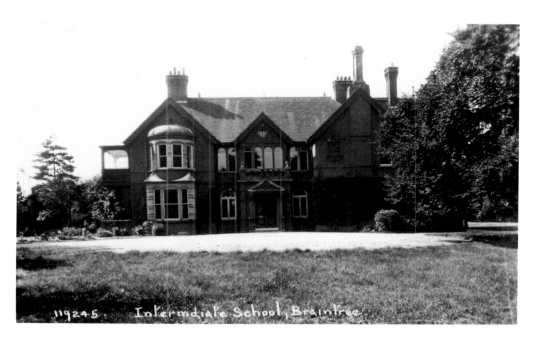

Intermediate School

Built with a mixture of Elizabethan and Jacobean styles for Sydney Courtauld between 1885 and 1887, Bocking Place had six reception rooms and fifteen bedrooms and was occupied by the Courtauld family until 1922. As this postcard, mailed in 1936 shows, it had become the Intermediate School, and was then part of Tabor High School until 1994. Bocking Place is now a development of nine luxury apartments and four executive houses.

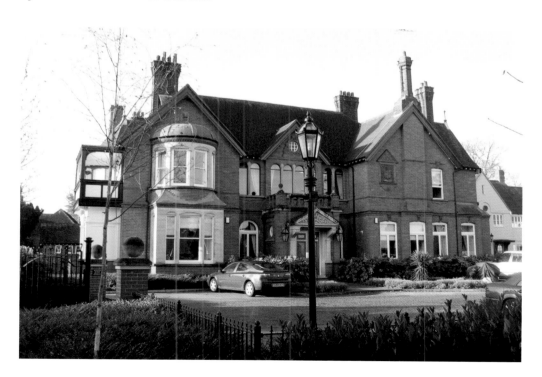

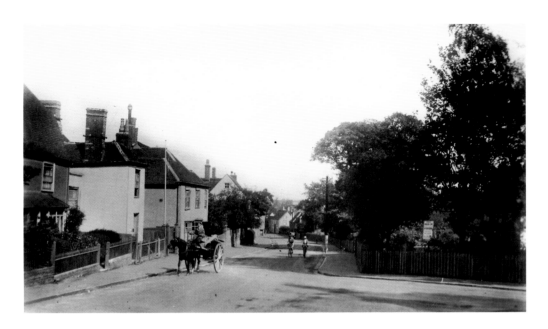

Bradford Street

This street contains some of the finest timber-framed buildings in the country, some dating back to the thirteenth century and maybe earlier. The building seen behind the horse and cart is The Old House, built in the second half of the sixteenth century and is now a guest house. Little has changed in this scene apart from street lighting and the inevitable traffic signs.

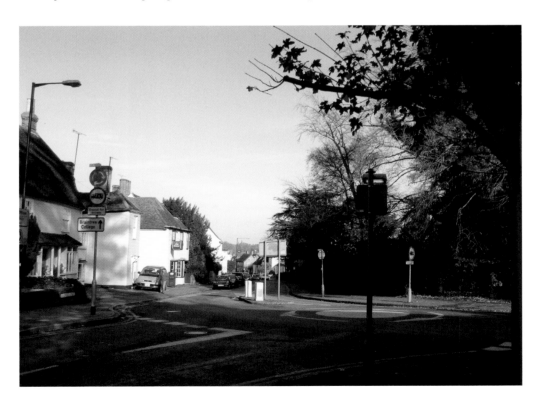

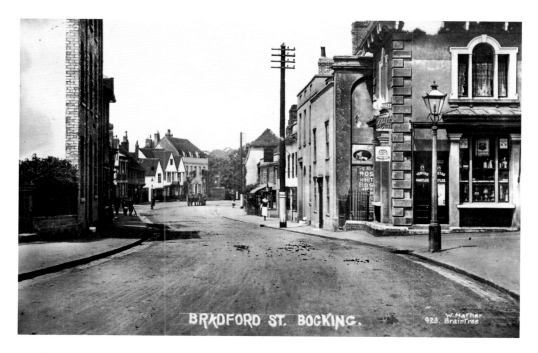

Bradford Street

The shop on the right is Durham's which sold household items including oil, paraffin and gas mantles. The property has also been a public house, The Cardinal's Hat and Cardinal's Garage. The last large three storey building on the left-hand side of the street is Maysent House, which for many years was the Queen's Head public house; it has an eighteenth-century facade but some parts date back to the fifteenth century.

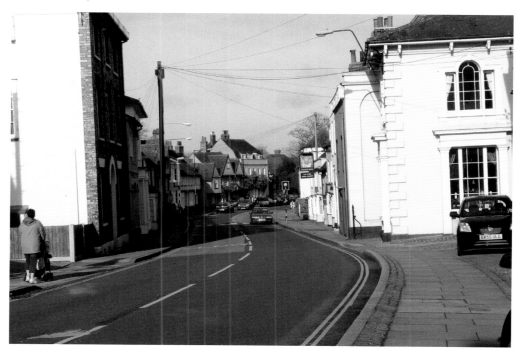

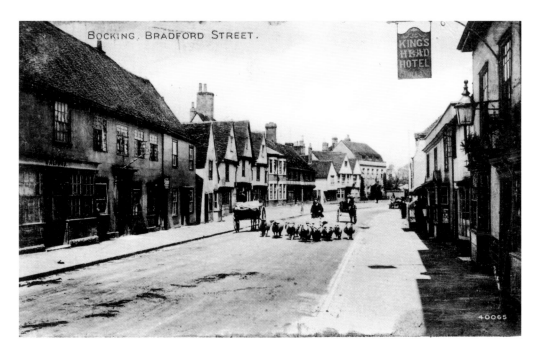

Bradford Street

The Woolpack Inn, seen behind the horse and cart, was an important coaching inn; the two outer wings were built *c.*1590 and the central section, *c.*1660. Further along is another building with three gables, Wentworth House, some parts of which date back to the fourteenth century; having been divided into three flats in the nineteenth century, renovation began in 1967 to restore it to its former state. Today, motorists would probably not be too pleased to come across a flock of sheep being driven along the road!

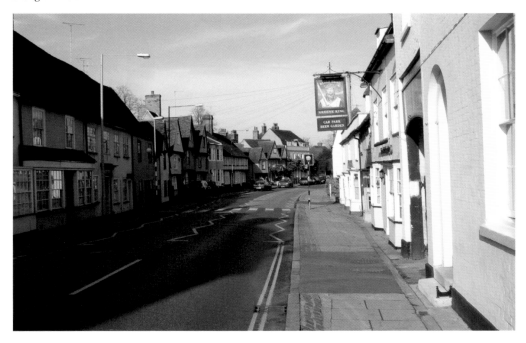

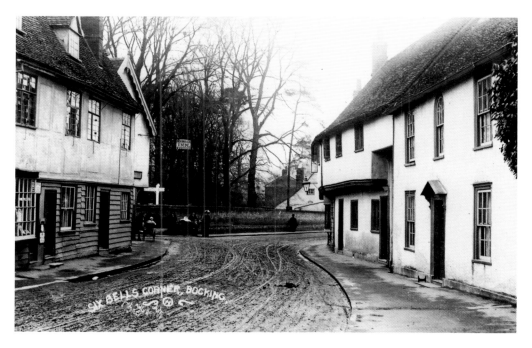

Six Bells Corner

In this postcard, *c.*1900, the first of the houses on the left was a post office and beyond them can be seen the gable of the original Six Bells Inn. Attached to an outside wall of the inn was a sixteenth-century carved wooden figure called 'Old Harkilees'. The new buildings now seen beyond the junction belong to Braintree College.

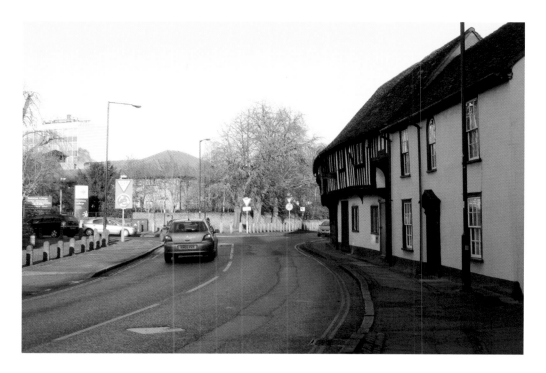

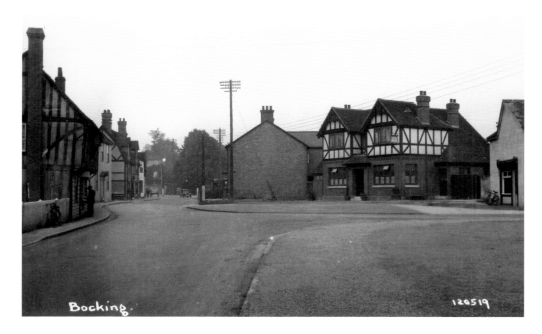

Six Bells Corner

The old Six Bells Inn was demolished in 1932 and replaced by this new building, built further back from the road. 'Old Harkilees' was put on the new inn, between the gables, but can now be seen in Braintree District Museum; the property is no longer a licensed premises. The sixteenth-century cottages on the left were recommended for demolition in the 1970s, but were listed as being of historic and architectural interest. The Tudor House was restored and at one time was the home of Braintree Museum.

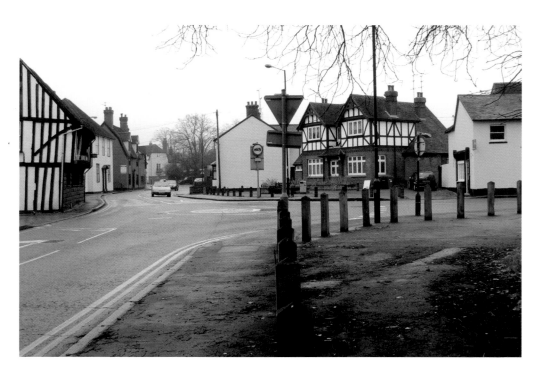

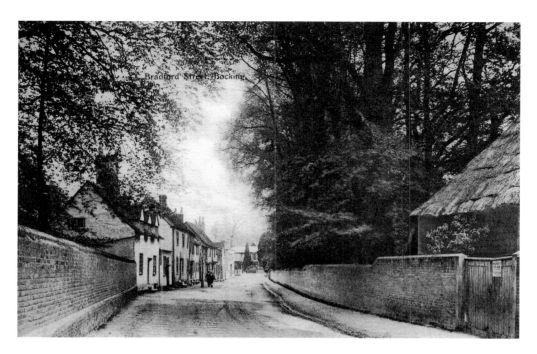

Bradford Street

These views taken looking towards the convent show many changes – the workmen's cottages seen on the left, have gone and the white building just beyond the parked cars is the Salem Strict and Particular Baptist Church. The most recent change is the mini roundabout giving access to a new road, River Mead, and a small housing estate.

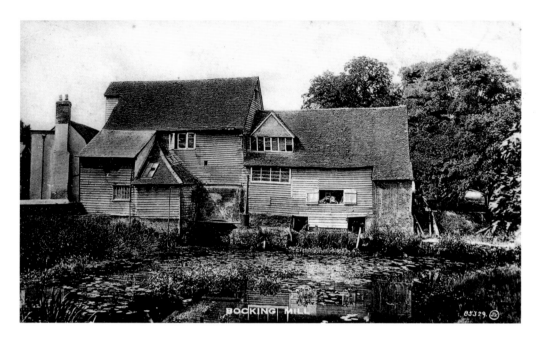

Bocking Mill

Also known as Cane's Mill, this beautiful mill was built in 1580. Although it was used in connection with the cloth trade, it was predominantly a flour mill powered by the River Blackwater before being converted to gas and then electricity. In 1998, after being unused and empty for some years, it was restored and converted into the interesting private residence seen today.

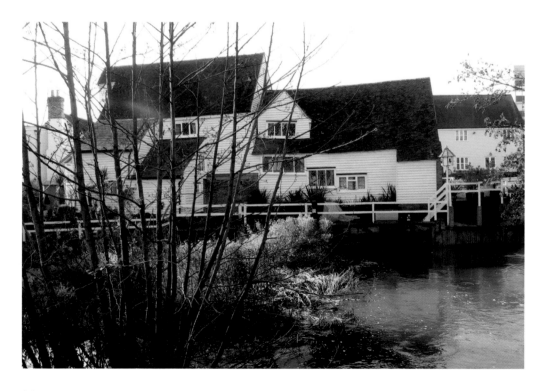

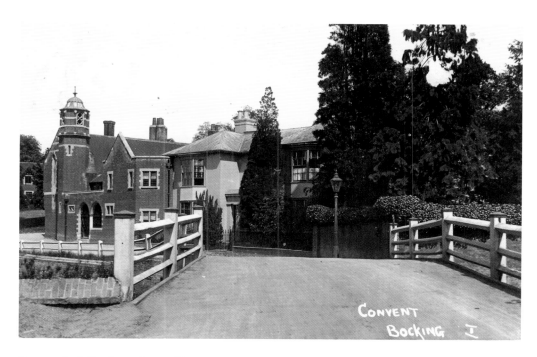

Convent of the Franciscan Sisters

Fulling Mill House, seen on the right, was lived in by several generations of the Nottage family. As Bridge House it was the home of Elizabeth Courtauld, who wrote in her will that it should become a convent. The Chapel adjoining the house was built in 1899. The old wooden bridge over the River Blackwater was rebuilt in 1926/7 and under the lamp two dolphins can be seen which are from the Arms of Bocking.

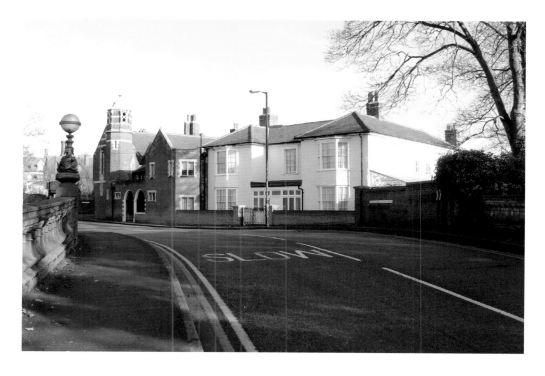

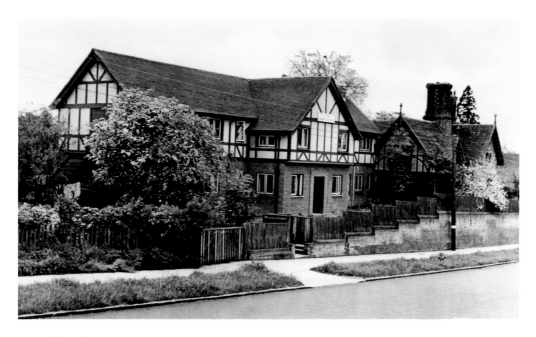

Broad Road

Run by Franciscan nuns, the St Francis Nursing Home provided residential accommodation and nursing care for the elderly. Despite campaigners fighting to prevent its closure, it closed in 2003 and was demolished in 2007/8. This area is still being developed – the new road is Elizabeth Lockhart Way and the new flats are St Francis' Place.

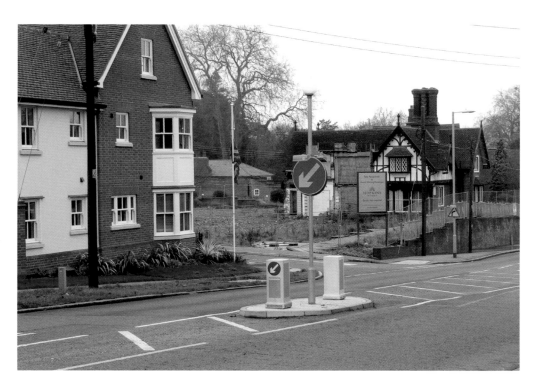

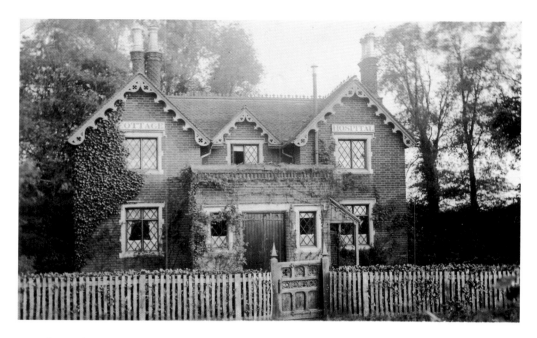

Broad Road

Originally two cottages, the Cottage Hospital opened in 1871. It was enlarged and renovated in 1897 in commemoration of Queen Victoria's Diamond Jubilee at which time it had seven beds. By 1902 the number of patients had risen to forty-seven. The William Julien Courtauld Hospital in London Road (see page 87) was built to replace it and although today it is a private house, its external appearance has not changed significantly.

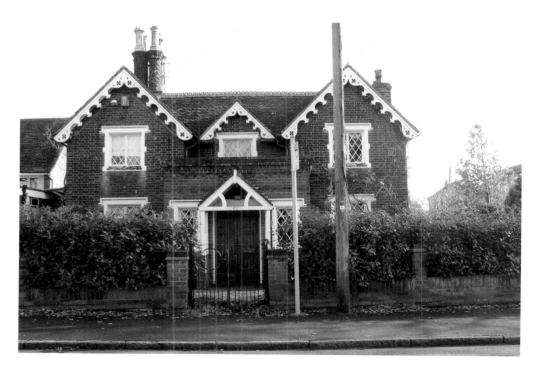

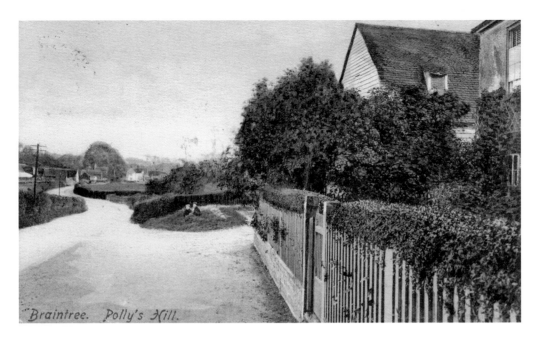

Polly's Hill

No-one seems to know why this part of Church Lane has this name although it is marked as such on old and new maps. Until 1906 the building with the pitched roof was used by Ridleys Brewery. Since this card was posted in 1914 many trees have grown and a mini roundabout added to give access to Church Meadows and a new housing estaste.

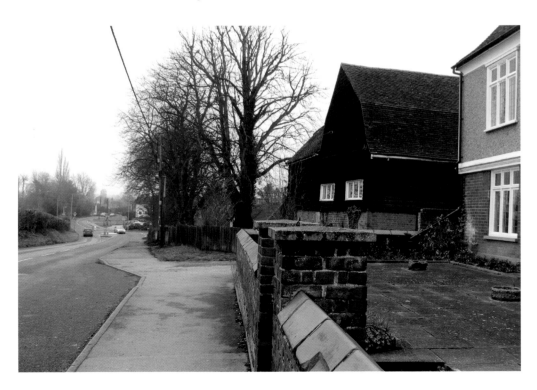

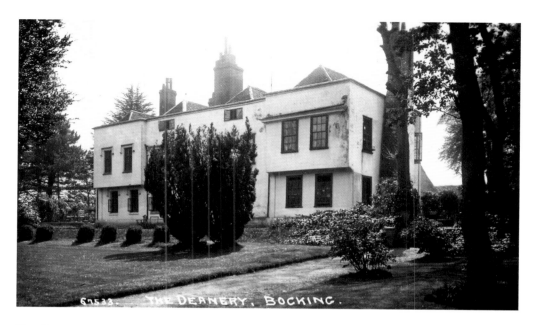

The Deanery

Some parts of the Deanery are thought to date from 1300 when it was a simple priest's house. It has been altered over many years; by 1565 it had been made suitable for the new Dean of Bocking, Dr James Calfhill, and was officially 'The Deanery'. Christopher Wordsworth, younger brother of the poet, William, was Rector and Dean of Bocking from 1808 to 1816. By the early 1980s it had passed from church hands to private ownership and became 'The Old Deanery', which is now a residential care home.

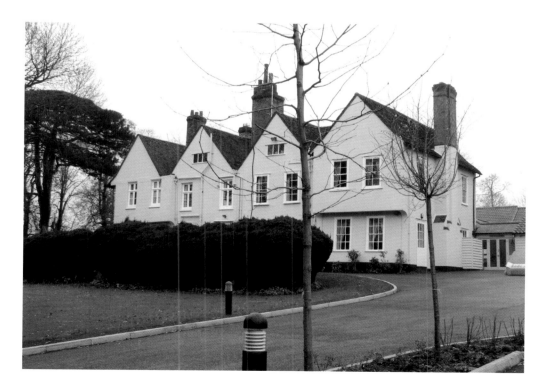

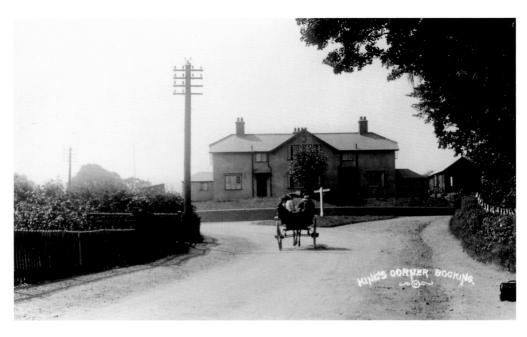

King's Corner

The slow, peaceful way of life captured on this postcard sent in 1911, showing the junction of Church Street with Deanery Hill, has been replaced by the faster pace of modern day living.

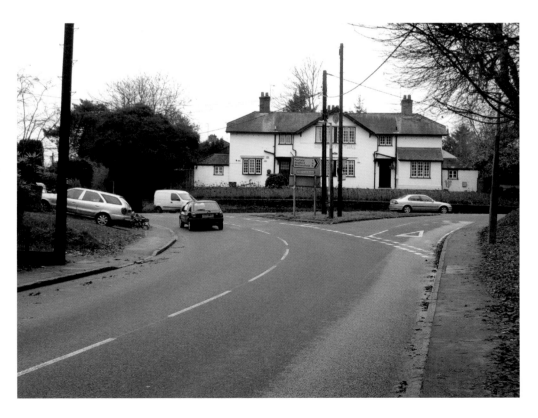

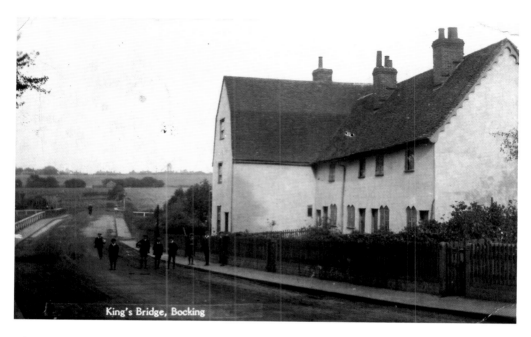

King's Bridge, Bocking

King's Bridge

The building on the right of this 1920s view, taken looking down the hill from King's Corner, was once a workhouse. Today, high on the wall to the left of the red door is set a dolphin and the date AD1500. The dolphin is part of the Arms of Bocking and comes from the crest of William Courtenay, Archbishop of Canterbury in the fourteenth century; the English branch of a French family, they had incorporated the dolphin to show pride in their past connection with the Greek Empire.

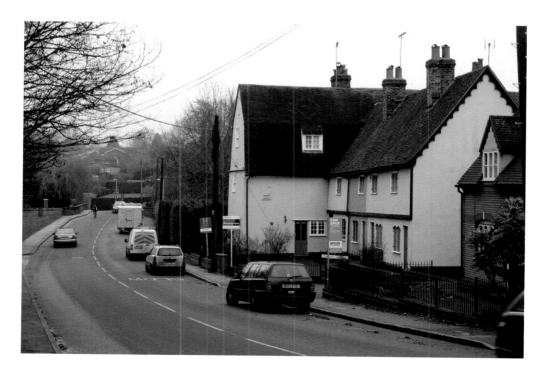

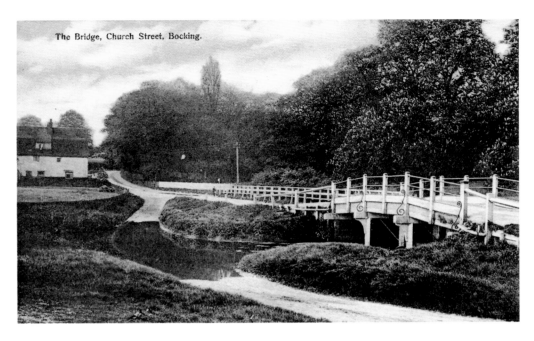

The Bridge, Church Street, Bocking.

The Bridge, Church Street

Posted on 22 September 1905, this postcard shows the wooden bridge over the River Pant; the ford beside it was probably used to water animals and clean horse-drawn vehicles. This ceased when the new bridge was completed in 1914 and named King's Bridge to commemorate the coronation of George V.

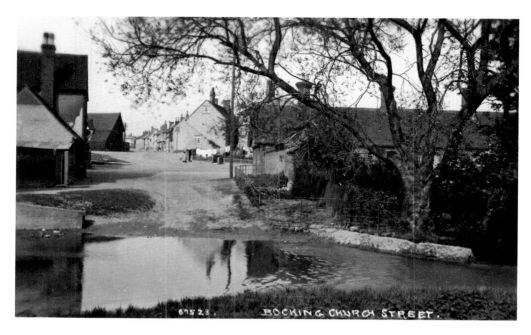

Bocking Church Street

The River Pant has occasionally flooded this area, so in response to extensive construction on both sides of the river, a new bridge has been built. Hopefully residents will now be able to keep their feet dry!

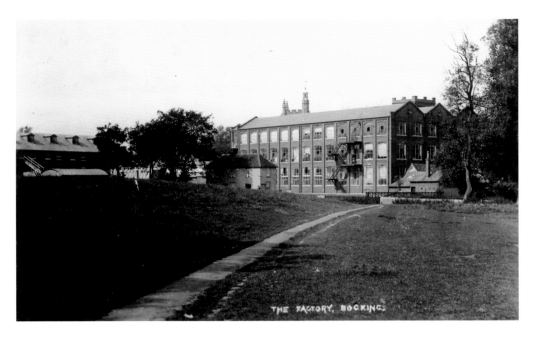

The Factory

Samuel Courtauld bought an old mill here in 1819 which he altered and extended to become the factory seen in this postcard, sent in 1915. Now, although the factory has gone, to be replaced by more housing, the tower of St Mary's church is still visible beyond the new building.

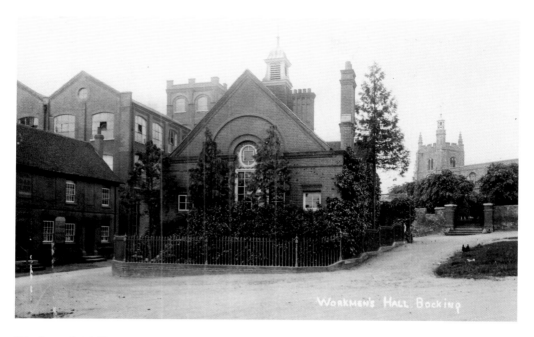

Workmen's Hall

The hall was built in the 1880s by the Courtauld family for their employees, many of whom would also have visited the Royal Oak public house seen on the left next to the factory. The building of St Mary's church was probably begun in the reign of Edward III and as the manor of Bocking was under the jurisdiction of Canterbury Cathedral, the priest was known as a Dean. Today it is St Mary's parish hall.

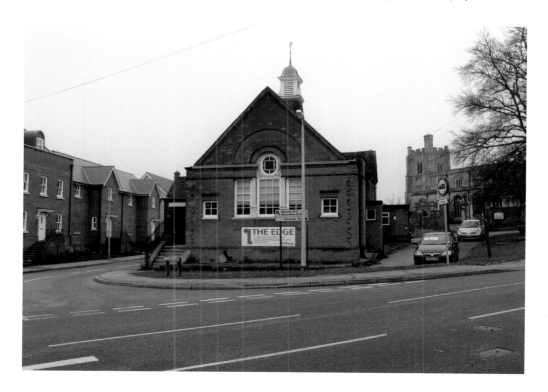

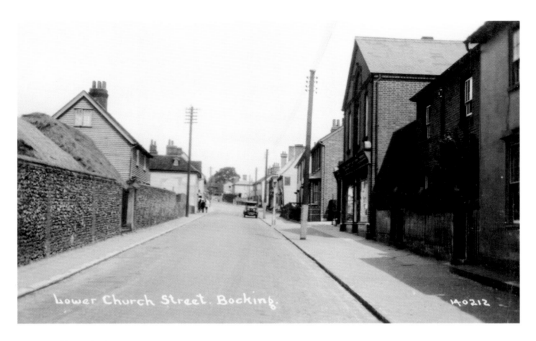

Lower Church Street

In 1874, the Braintree & West Essex Co-operative Society Ltd opened a new branch in Church Street in a simple double-fronted cottage; by 1881 the society had moved to larger premises and in 1913 a new store was built on land adjacent to their second store. Seen on the right of both these views, the store is still trading today.

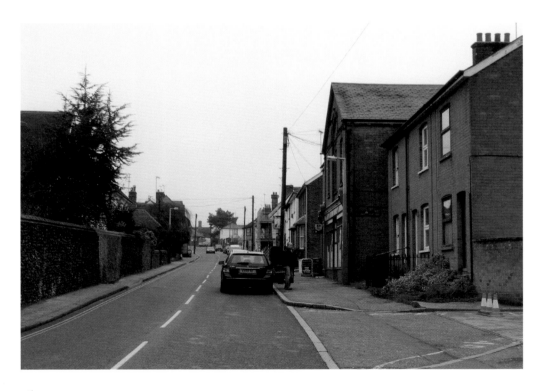

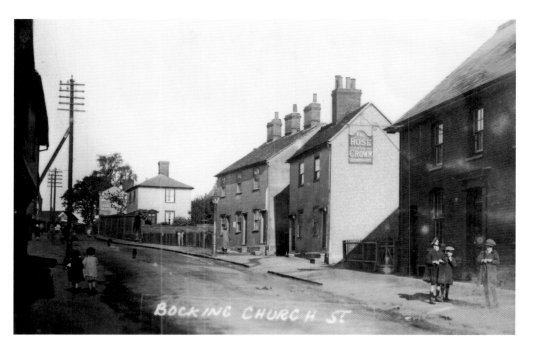

Bocking Church Street

Apart from the vehicles and road markings, not much has changed during the years separating these two views. The Rose and Crown public house probably began life as a beer-house, and in the census taken in 1871 it was listed as an alehouse.

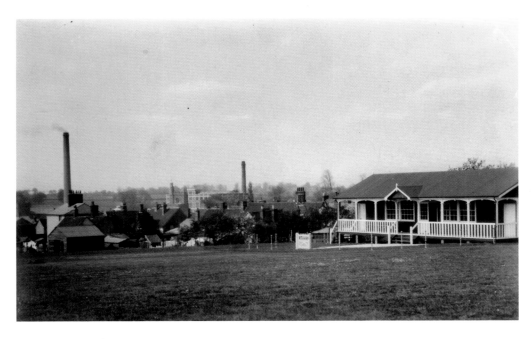

Bocking Church Street

Although these playing fields are still used regularly, the sports pavilion is no longer used and has fallen into a very dilapidated state.

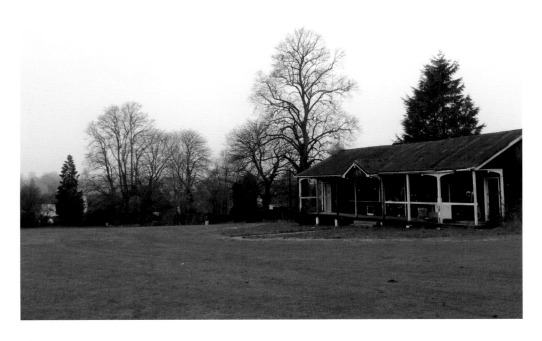

FENNES LANE, BOCKING.

Fennes Lane

Although this is still a narrow lane leading to the Fennes Estate and the Edith Borthwick School, there has been considerable development during the time that has passed between these views being taken. Behind the hedge on the right are the bungalows of St Nicholas Gardens and at the junction with Bocking Church Street is an impressive village hall.

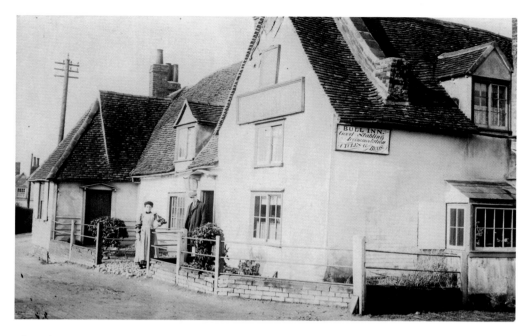

Church Street

The Bull Inn was a large premises and records show it as being open by 1769. It was a popular meeting place in the late 1700s and early 1800s, being used by the town's Freemasons, Courtaulds and the Bocking Cricket Club. Demolished in 1970, the site is now occupied by the house and gardens of 171 Church Street.

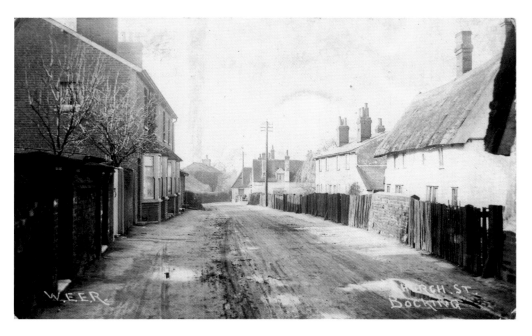

Church Street

The rough road has been replaced by a modern surface and pavements and while nothing remains on the right from the old view, much on the left remains the same, with the wall and gates of Hill Crest House, built in 1904, and the terrace of houses beyond.

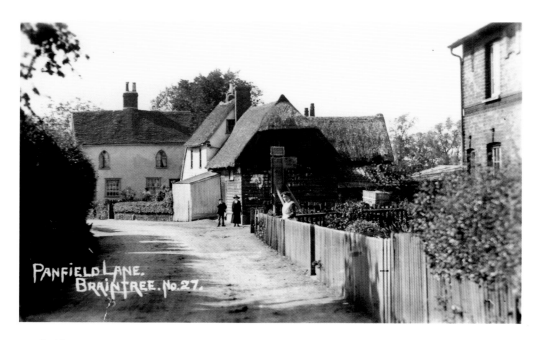

Panfield Lane

This scene taken about 1900 shows Spaldings Farm on the right. The shed in the centre was used as a pay-box where the public paid to watch Manor Works (Crittalls) football team play in a field at the back of the farm. Today, the brick cottage on the extreme right is all that remains from the old view.

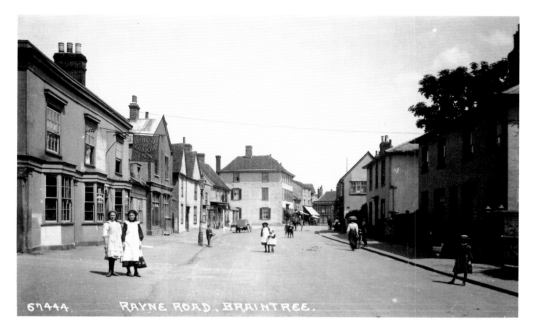

Rayne Road

The photographer posed many of the people for this postcard, but it would not be advisable to try this today. The three-storey building in the centre of both scenes is Twyford House and Charles Edward Joscelyne was living here in 1900. During the First World War it became a hostel for women working on munitions in the local factories. For many years it was an Eastern Electricity showroom and is now Mill House Fabrics.

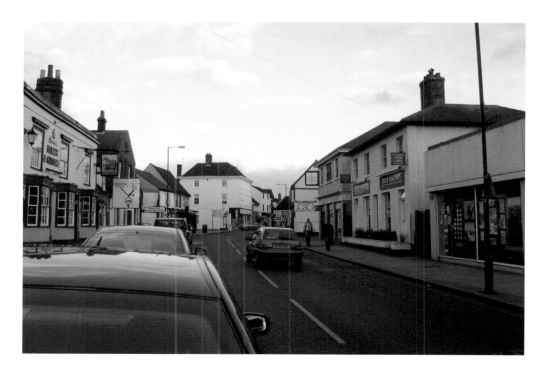

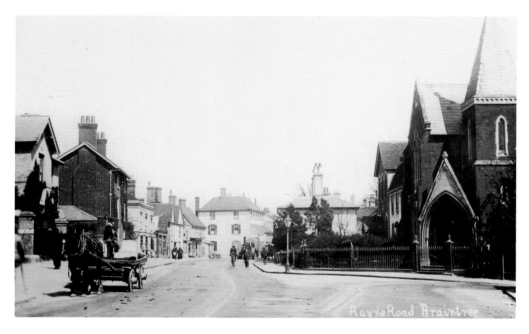

Rayne Road

This postcard shows a much slower pace of life, with a horse and cart, a bicycle and even a traction engine visible in the background. Standing on the corner of Sandpit Lane, the Methodist church was demolished in 1988 to make way for the George Yard development.

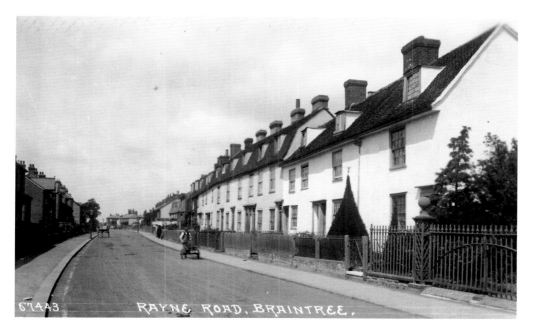

Rayne Road

Some of these three-storey lath and plaster cottages were thought to have been used by silk out-workers, as the south facing windows would have given them good light. The view from their windows has changed considerably, the houses opposite having gone to make way for George Yard Shopping Centre and the junction with Pierrefitte Way.

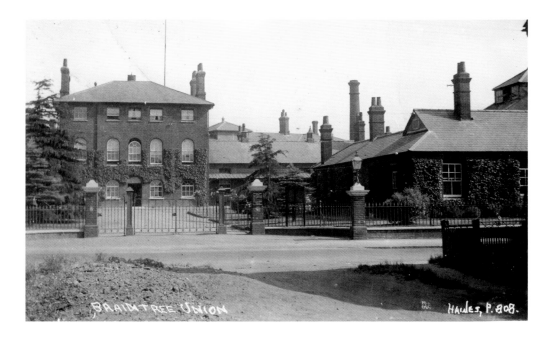

Rayne Road

The Union Workhouse, shown on this card postmarked 3 November 1925, was built in 1837 and was known by local people as 'The Spike'. A large infirmary was added circa 1849 and many modifications were carried out in the following years; the building on the right was erected in 1895 to give tramps a place to spend a night. When the National Health Service was formed in 1948 it became St Michael's Hospital, and by 1973 this Grade II listed building was being used for the care of the elderly. Today this site is being redeveloped as Old St Michaels, a complex of apartments, houses and offices.

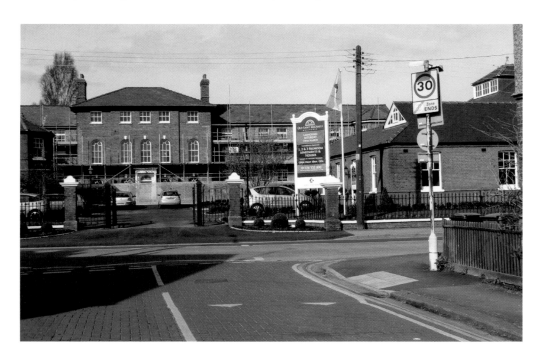

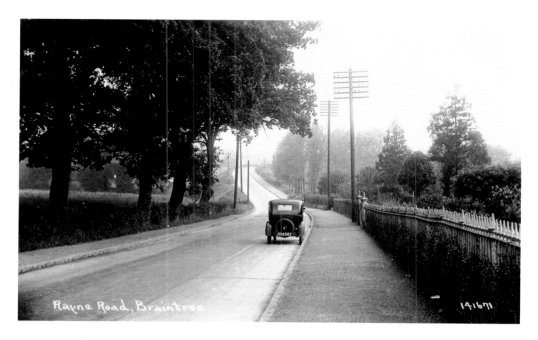

Rayne Road

With no recognisable reference points to look for, this view proved difficult to identify. Hopefully it has been correctly identified, which is looking uphill towards Braintree and the roundabout at Springwood Industrial Estate. As the car on the postcard probably belonged to the photographer, this has been replicated in the new view.

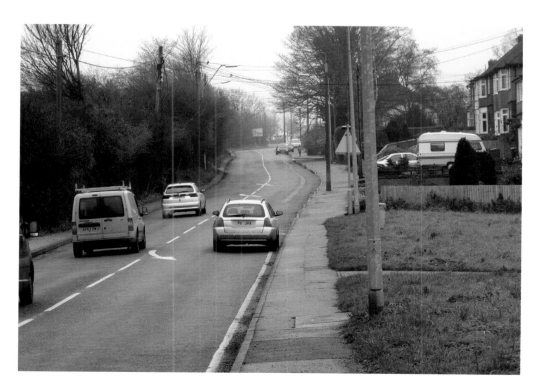

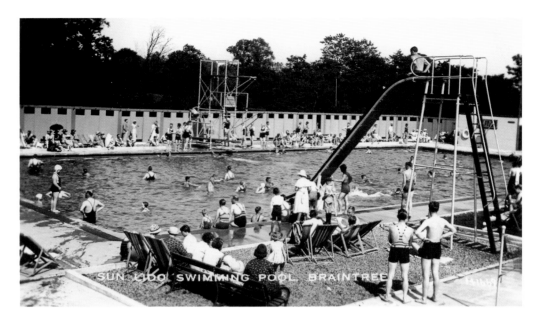

Rayne Road

In 1934, as well as a swimming pool, the Sun Lido had a children's paddling pool, a boating lake and an area for tents and, later, caravans. With attendants always present, parents could safely let their children use the paddling pool and boating lake (which was very shallow). It was regularly used by USAF servicemen and their families and by 1950s there was a café, two tennis courts and a Brylcreem machine! Today, nothing remains of this once popular venue except the name (see page 69).

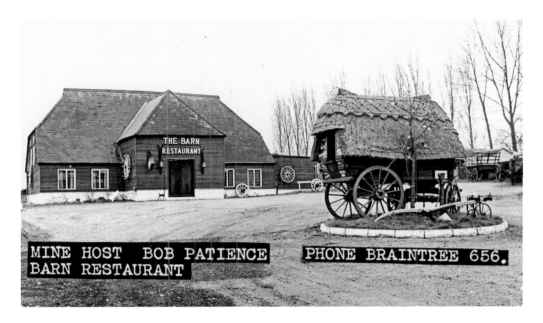

MINE HOST BOB PATIENCE
BARN RESTAURANT

PHONE BRAINTREE 656.

Rayne Road

The Barn Restaurant was a venue used by many well-known stars, including The Prodigy in the early 1990s. In November 1972, George Ince from London murdered Bob Patience's wife, Muriel, and attempted the murder of Bob and his daughter, Beverley, in their home near the restaurant. The Barn was demolished in 1997 and replaced by a 110-house development, Sun Lido Square Gardens.

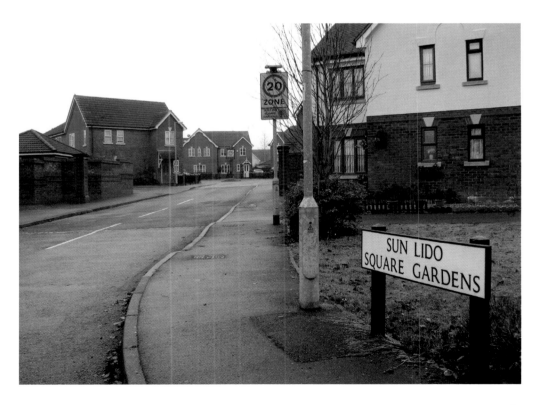

SUN LIDO SQUARE GARDENS

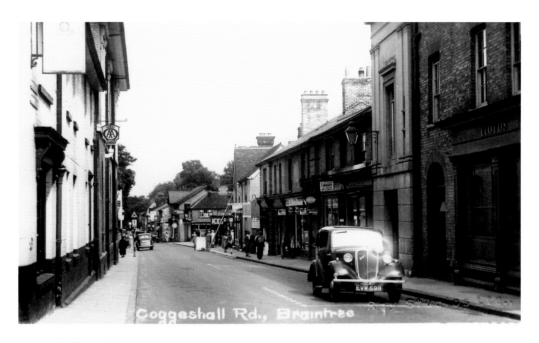

Coggeshall Road

The most noticeable difference between these two views is the absence of the buildings on the extreme right which were destroyed by a bomb on 14 February 1941. They were never rebuilt and thus gave rise to the open aspect seen today.

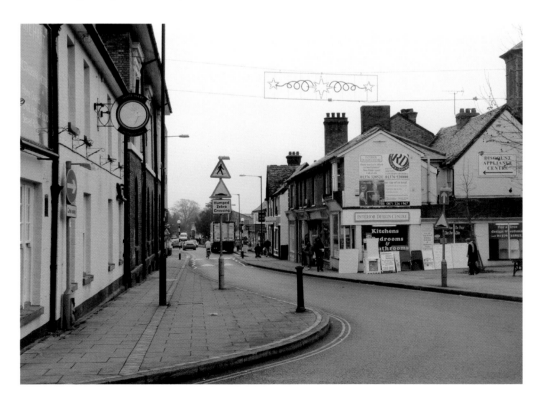

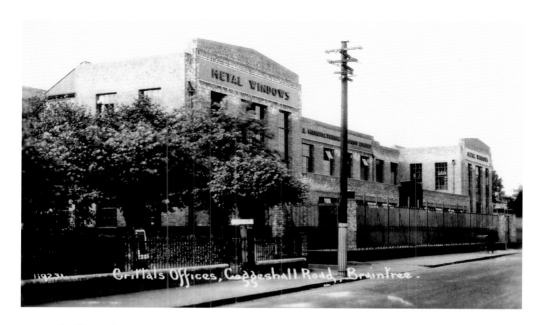

Coggeshall Road

Crittall Windows Ltd had factories all over the world and the Braintree factory spread from Coggeshall Road to Manor Street. The offices were built in 1927 and, when the factory was demolished in 1992, after almost a hundred years of production, their range included fireproof doors, fire escapes, conservatories and patented airtight manhole covers. When the new Coventry cathedral was built in 1958, Crittalls received a commission to construct the great west screen, which took two years to complete. The site is now a housing development.

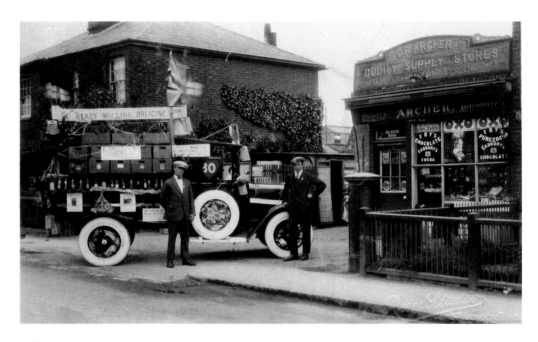

Railway Street
The vehicle, decorated for the annual carnival, belonged to the Archer family, who had bought Jordan's Mineral Water Company. The shop was called the Oddity Supply Stores: Confectioner, Tobacconist and Greengrocer, and given the range of items for sale, some advertised on the windows, it would have been an appropriate name!

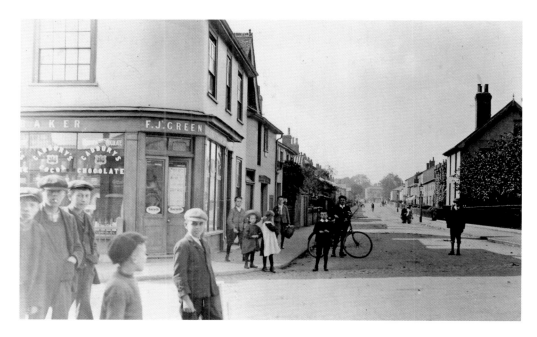

Railway Street

This card, with a postmark for 1914, shows the junction with Manor Street and the shop of F. J. Green, Baker & Confectioner. Over the window of the bakehouse was a carved wooden lintel said to have come from the old south porch of the parish church and which is now in Braintree District Museum.

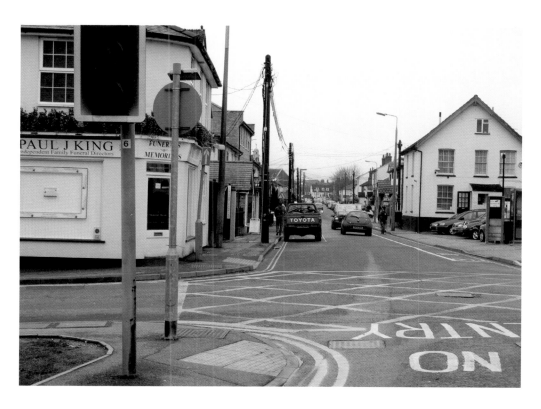

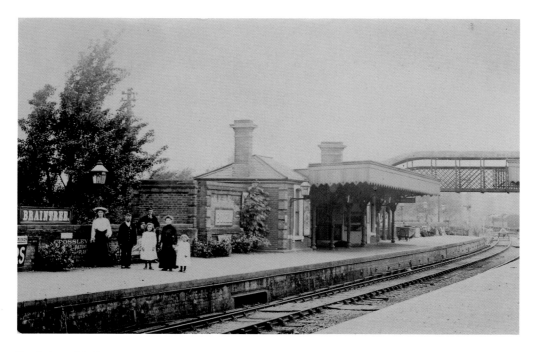

Braintree Station

When the first train arrived in Braintree on 7 October 1848, the original station building was a wooden structure and was in Railway Street; it moved to its present location in 1889. In 1963 Doctor Beeching proposed the closure of the six mile stretch between Braintree and Witham, but, due to the work of local pressure groups, the closure was stopped and in 1977 British Rail electrified the line.

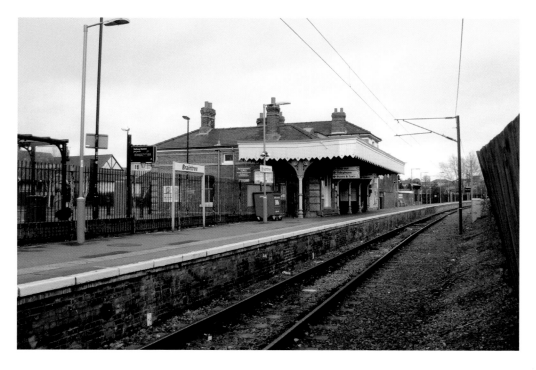

Coggeshall Road

Great Bradfords farmhouse stood opposite the Jubilee Oak at the junction with Cressing Road. The site of the farmhouse and adjacent dairy was donated to the Abbeyfield Group by Jean and Peter Davey in 2002. The original buildings were demolished and the Abbeyfield Great Bradfords House was opened by Baroness Bottomley of Nettlestone on 13 July 2007.

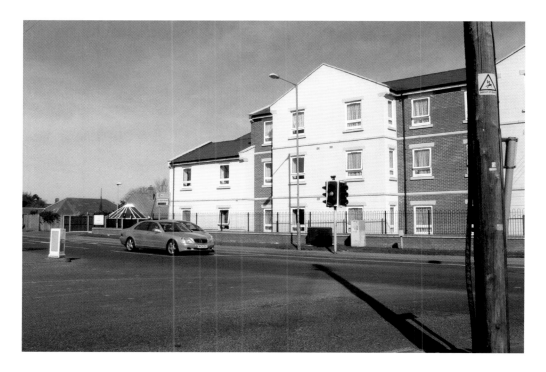

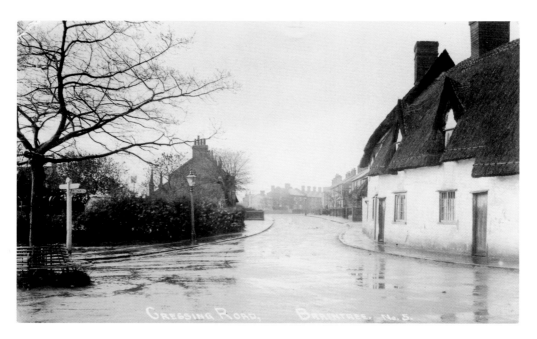

Cressing Road

Planted to commemorate Queen Victoria's Golden Jubilee, the oak tree seen on the left of this card posted on 7 January 1911 gave rise to this location being known as Jubilee Oak Corner. By 1986 the tree had gone, to be replaced by a traffic island sprouting road signs and traffic lights.

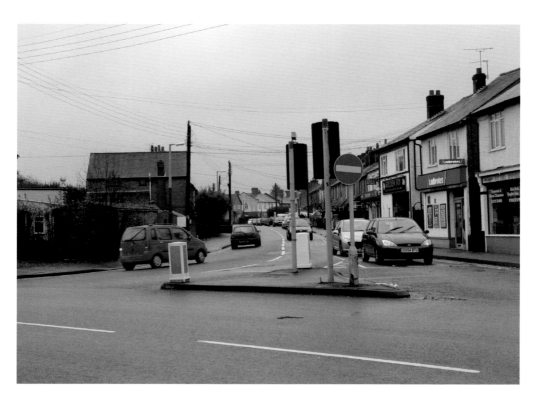

Cressing Way

These houses, described as the 'first in England which were modern as opposed to traditional form' they were built by the Crittall Manufacturing Company – Unit Building and were homes 'fit for heroes'. They were designed by C. H. B. Quennell and W. F. Crittall and work commenced in 1919. A unit was a revolutionary one metre or parts there of and initially no wood was used; floors and roofs were cast in concrete, walls were cavity concrete blocks (using aggregate dug nearby), windows had steel frames, and in some houses, the doors, door frames and staircases were steel. In the late 1930s, to avoid confusion with Cressing Road, it became Clockhouse Way after the farm whose land the estate occupies.

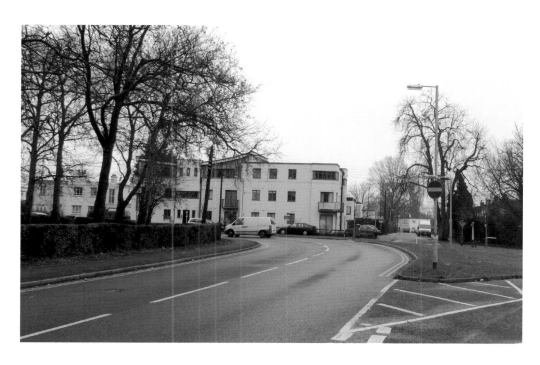

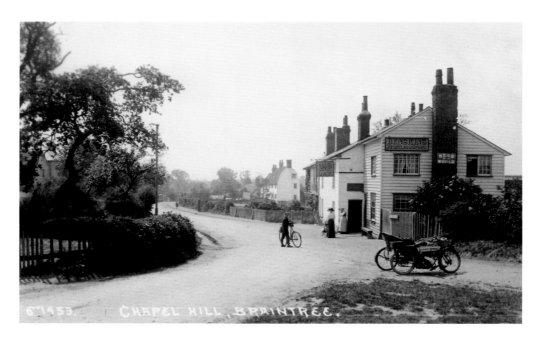

Chapel Hill

Records show that The Oak public house, seen on this card posted in 1913, was trading by 1860. The track on the right led to Parsonage Farm and is now Lakes Road. The old building was replaced in 1930 by the one seen today. No longer a public house, having closed on 28 June 1981, it has been used by a variety of businesses.

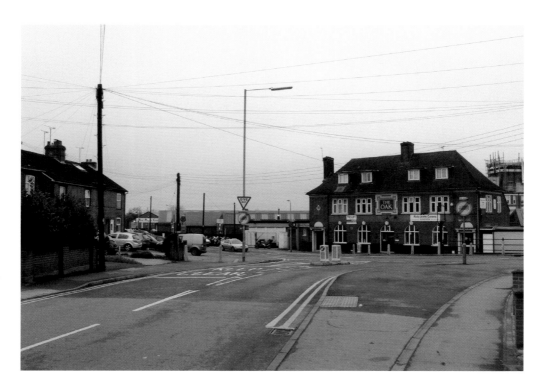

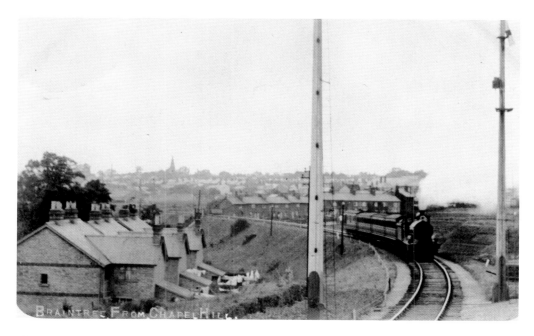

The Railway

Leaving Braintree Station, the steam engine and its carriages pass behind the houses in Mill Hill which still remain but are now hidden from view. Used by many commuters to London, an hourly service links Braintree to the main line via Witham; a new station having been built to service the retail outlet village of Braintree Freeport.

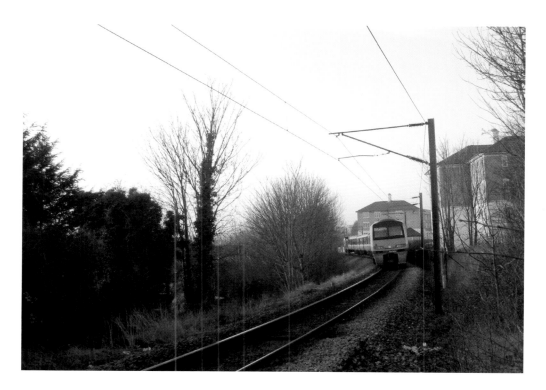

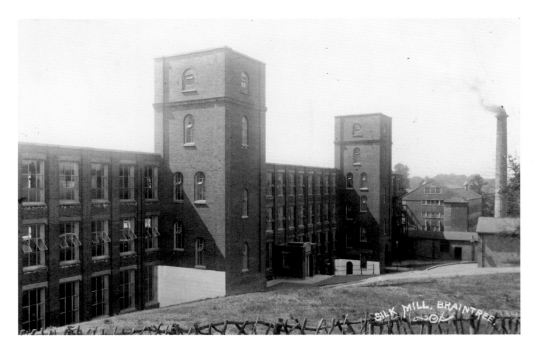

Courtauld's Mill

The Silk Mill at Chapel Hill was established in 1810 by George Courtauld. In 1909 most of the factory was destroyed by fire, the flames being visible from Chelmsford, and was rebuilt in 1910. When the factory was demolished, plans for the area included a 50,000 square foot supermarket. County planners rejected this in the early 1980s and planning was later accepted for more housing.

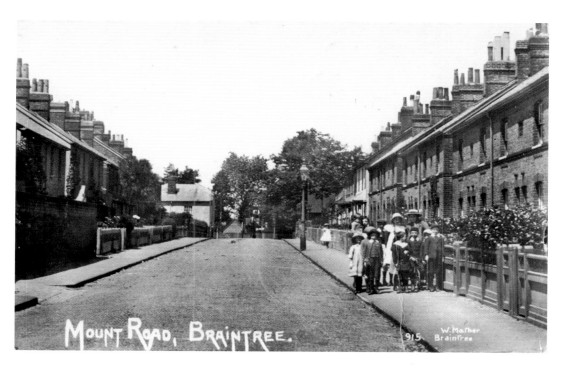

Mount Road

One of the quieter roads in the town, it is kept that way now by parking being restricted to residents only. The large house seen on the far left, where Mount Road joins Coggeshall Road, has gone and the corner is now occupied by Sainsbury's petrol station.

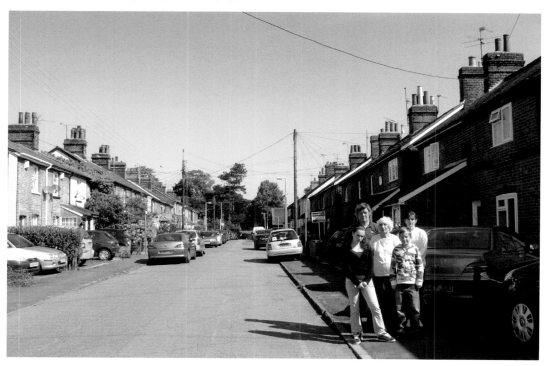

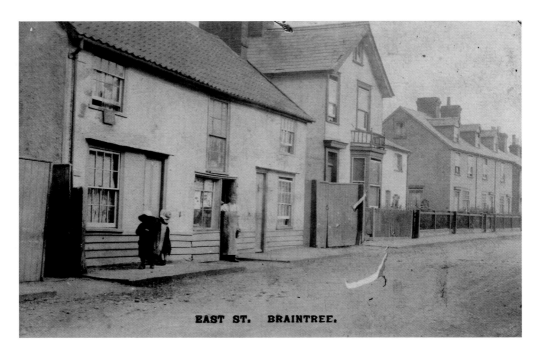

EAST ST. BRAINTREE.

East Street

Many tradesmen ran businesses from their homes as shown in this postcard. Although the shop and adjoining houses have gone, many of the old buildings have survived the passage of time and the advent of motor vehicles, many of which use East Street as a shortcut between Manor Street and Coggeshall Road.

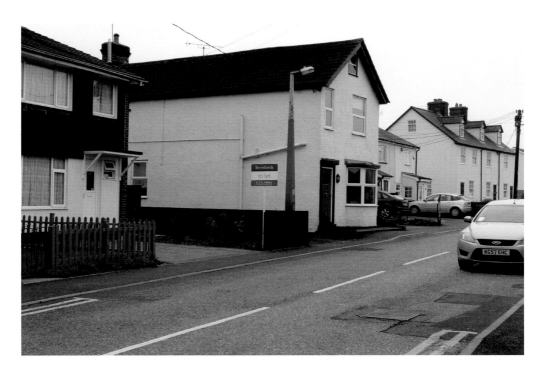

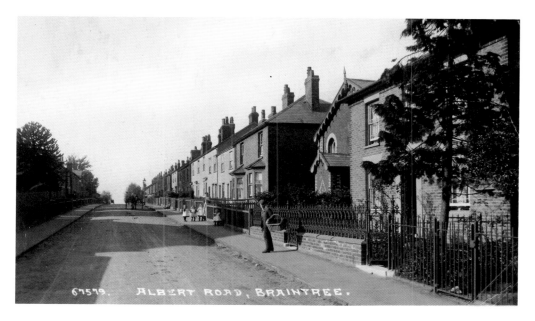

Albert Road

Posted in 1913, this card shows a quiet road running between Coggeshall Road and Manor Street; the small chapel seen set back from the road on the right, was Strict Baptist and the congregation moved to new premises near Braintree College. The chapel and several houses were demolished to make way for modern housing, and at the end of the road the roof of one of the new buildings in Trinovantian Way can be seen, named after the Iron Age tribe, the Trinovantes.

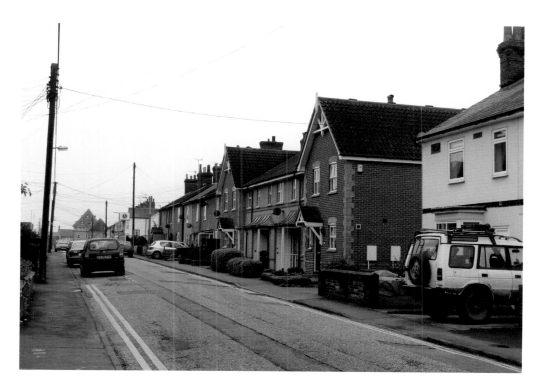

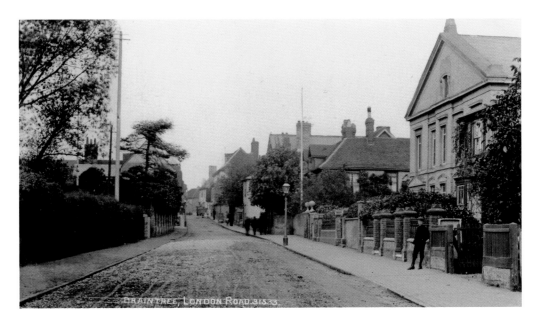

London Road

The Congregational church, on the right, was erected in 1832 on land given by Rev'd John Carter who was the pastor here for over fifty years. The major difference between the card that is postmarked 10 September 1906 and the new view is on the left, where in 1988 a new road was built between London Road and Rayne Road; it was named Pierrefitte Way after the French town that is twinned with Braintree.

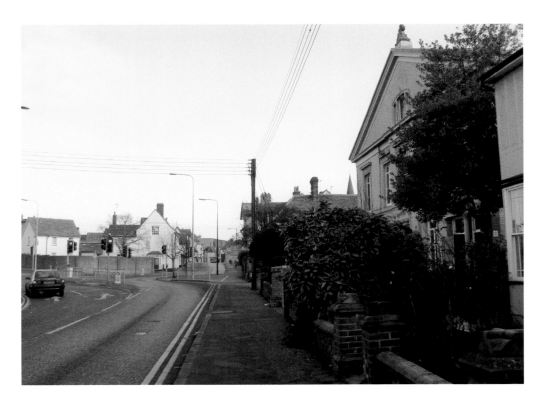

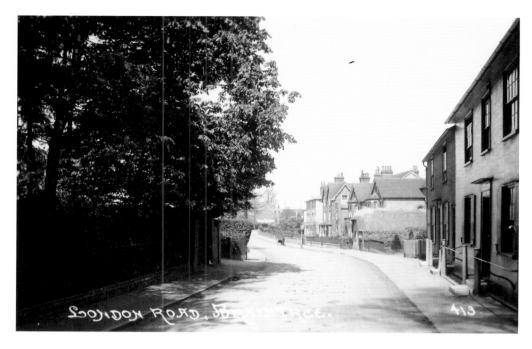

London Road

This card has been dated 9 March 1937 and shows the view looking towards the town. On the right now is the beginning of Godlings Way, built in the 1960s. Following complaints from the residents of the new road, a barrier was erected halfway down to prevent it being used as a shortcut to Notley Road. Eventually the barrier was removed, and in recent years speed humps have been put in place to control the speed of the traffic still using this road as a shortcut.

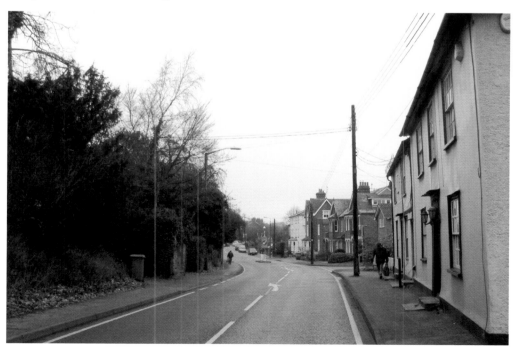

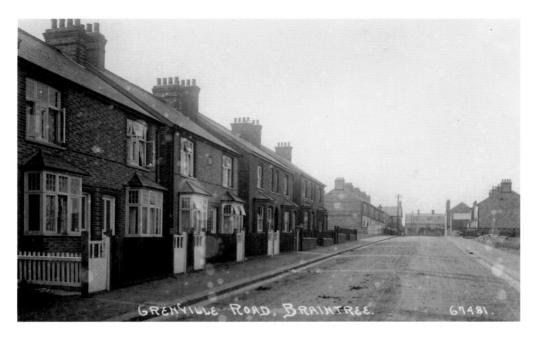

Grenville Road

This was the main route from London Road to Rayne Road, as seen in this 1920s postcard; it became a cul-de-sac when the Rayne Road end was blocked following the building of Pierrefitte Way in 1988.

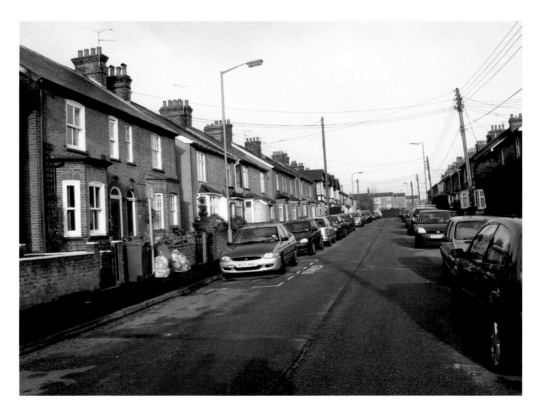

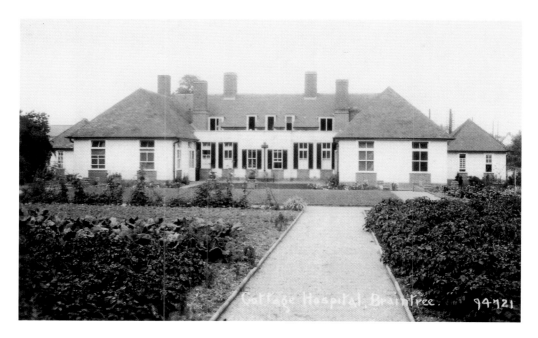

Cottage Hospital

The William Julien Courtauld Cottage Hospital in London Road was opened in 1921 with four wards. In 1988 there were plans to close this well-loved little hospital but it still survives today and is used mainly for maternity care, with A & E being transferred to Broomfield Hospital in Chelmsford.

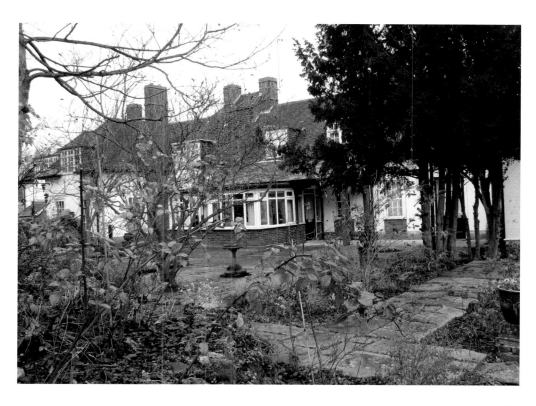

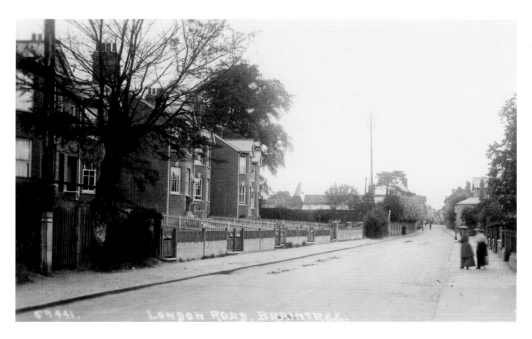

London Road

Posted in 1927, the sender writes 'nice weather for a change'. The semi-detached houses still remain, but, due to increased traffic and parking restrictions, most of the front gardens are now used for the residents' vehicles.

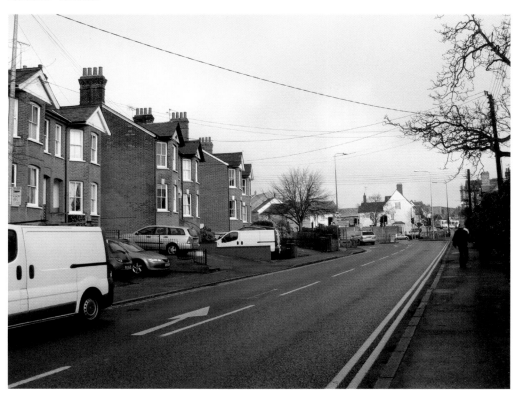

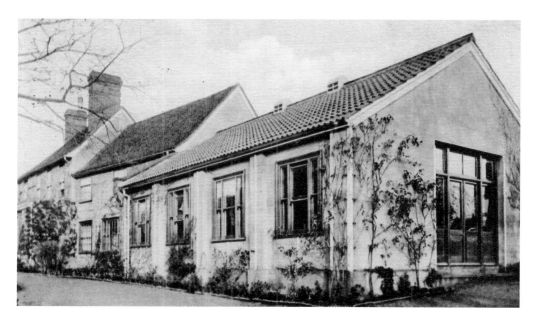

London Road

Written in French and sent to Paris, this card was posted on 28 April 1913 at Hawkshead in the Lake District. In a publicity brochure for the school it states that 'Blandford House High Class School for Girls is large and detached with extensive gardens, orchards and a paddock, and every attention is given to the health and happiness of the pupils'. For a number of years it was a doctors' surgery before the practice moved in late 2008, and at the time of this photograph the building is unused.

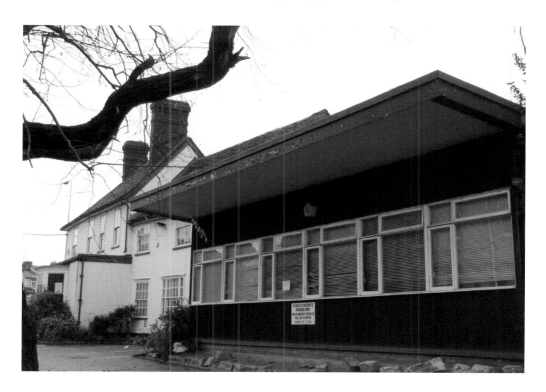

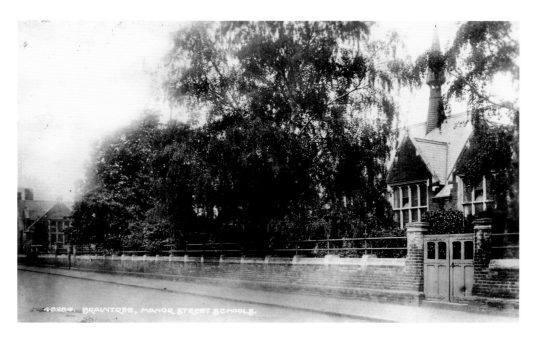

Manor Street School

Built in 1862 and financed by George Courtauld, it closed in 1990. In 1993, with funding from Countryside Properties, Carnegie UK and many others, the school re-opened as Braintree District Museum. The bronze statue by Faith Winter of John Ray, natural scientist (1627–1705), was originally sited outside Barclays Bank, Bank Street where it was unveiled in October 1986. It was moved to its present position in the grounds of the museum in 1995.

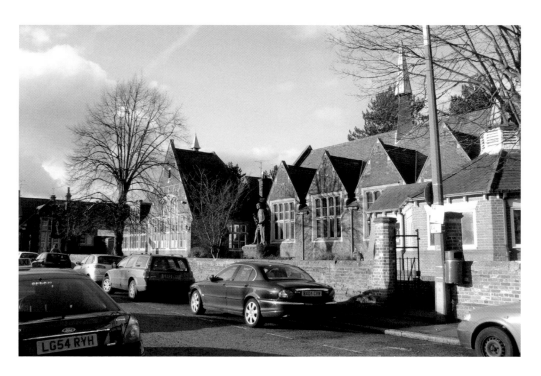

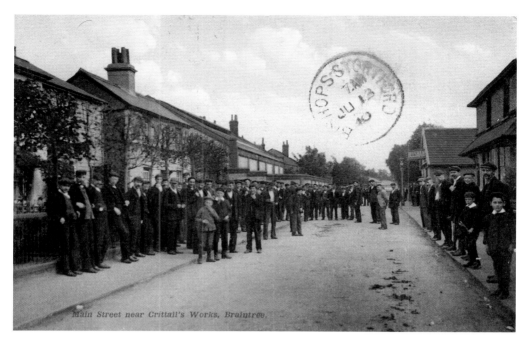

Main Street near Crittall's Works, Braintree.

Manor Street

Although the caption on this card, posted in 1910, states it is Main Street, it is in fact Manor Street and shows workers outside the Crittall factory. They had obviously been asked to pose for the photographer. After the factory's closure in 1992, the site was sold for housing and the estate on the left is the back of the one seen from Coggeshall Road (see page 71).

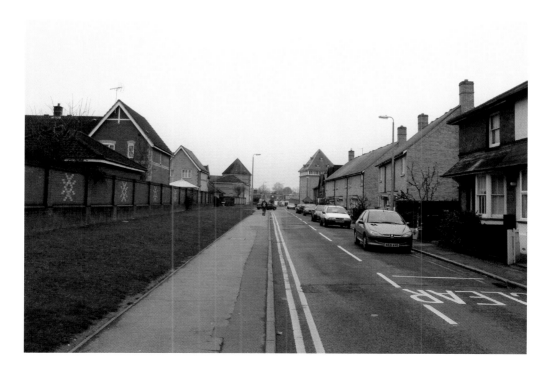

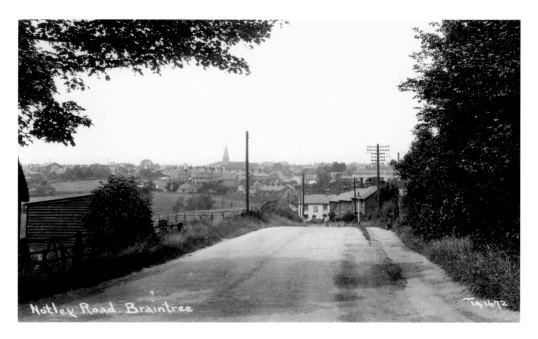

Notley Road

In both of these views looking downhill towards Braintree and the River Brain, the white building in the centre is the Rifleman public house. What was a semi-panoramic view of the town has become obscured by new buildings and trees.

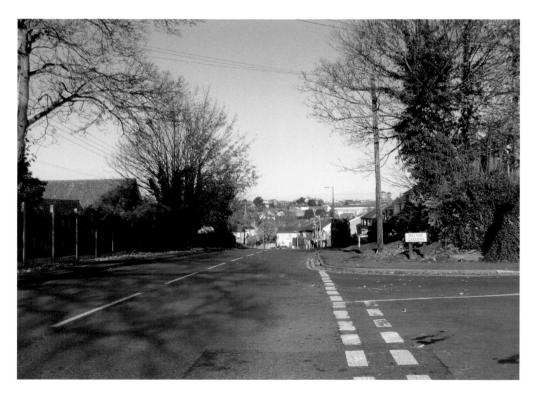

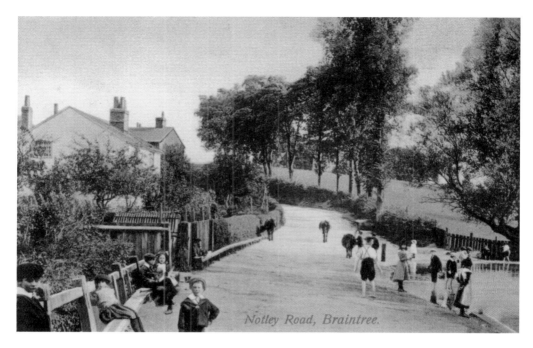

Notley Road, Braintree.

Notley Road

On this card sent in August 1906, some of the children are aware of the photographer, but most are enjoying what must have been a warm summer's day. On the left is a raised wooden walkway for use when the River Brain flooded the road. Although the level of the road is higher today, it is still liable to flood in extreme weather conditions.

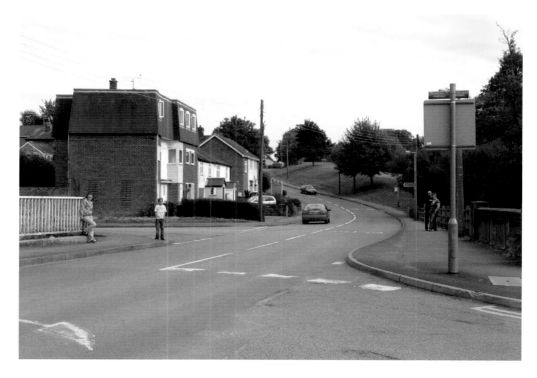

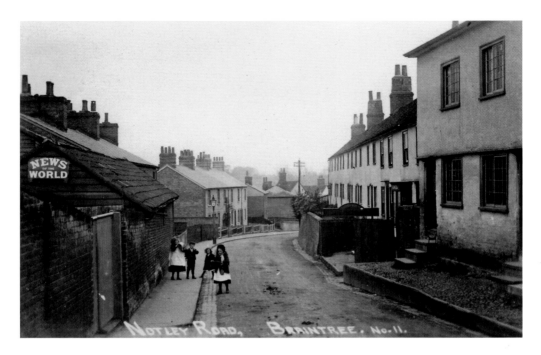

Notley Road

This view which was taken in 1910 shows Notley Road near its junction with South Street. The gates on the left lead to the yard of the Rose & Crown public house (see page 95). Gowers shop and bakery was on the right until it closed in 1990 after 148 years. It was a sad loss, their sticky currant buns were delicious! A chalet bungalow and its garden have replaced the terrace of houses seen beyond the bakery.

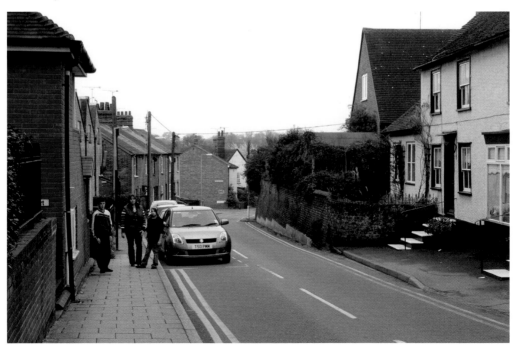

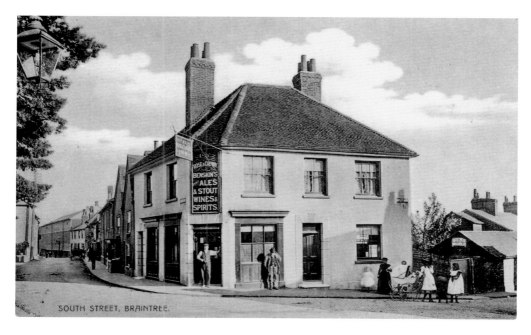

SOUTH STREET, BRAINTREE.

South Street

The Rose & Crown public house, shown here on this postcard sent in 1910, stood on the corner of Notley Road. In August 1965 the publicans moved to the new Rose & Crown in Masefield Road, and the old premises were demolished for road improvements, but, as can be seen, St Michael's Court was built on the same site! The 'new' Rose & Crown has now closed.

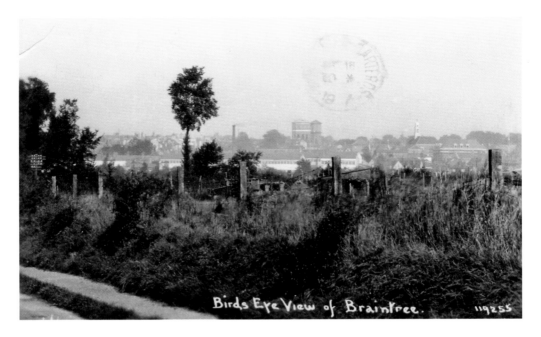

Birds Eye View of Braintree. 119255

Bird's Eye View

In the message on this card to The British Hospital in Montevideo, Uruguay in 1937 is written 'You won't know this place with all the new buildings'. The writer would probably be surprised to see that the only recognisable buildings in both views, taken from what is now a small playing field off Notley Road, are the town hall and the two water towers.

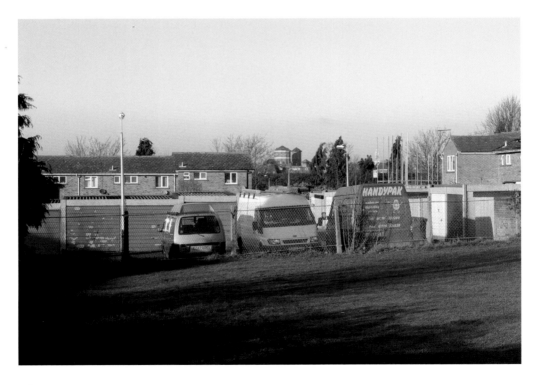